IF YOU'RE BORED WITH WATERCOLOUR READ THIS BOOK

To my sister, Nathalie

An Hachette UK Company
www.hachette.co.uk

First published in Great Britain in 2017 by ILEX, a division of
Octopus Publishing Group Ltd
Carmelite House
50 Victoria Embankment
London EC4Y 0DZ
www.octopusbooks.co.uk

Publisher: Roly Allen
Editorial Director: Zara Larcombe
Editor: Francesca Leung
Managing Specialist Editor: Frank Gallaugher
Editor: Rachel Silverlight
Writing and research: Alannah Moore
Admin Assistant: Sarah Vaughan
Art Director: Julie Weir
Designer: Louise Evans
Assistant Production Manager: Lucy Carter

ISBN 978-1-78157-404-1

A CIP catalogue record for this book is available from the
British Library.

Printed and bound in China

10 9 8 7 6 5 4 3 2

IF YOU'RE BORED WITH WATERCOLOUR READ THIS BOOK

VERONICA BALLART LILJA

ilex

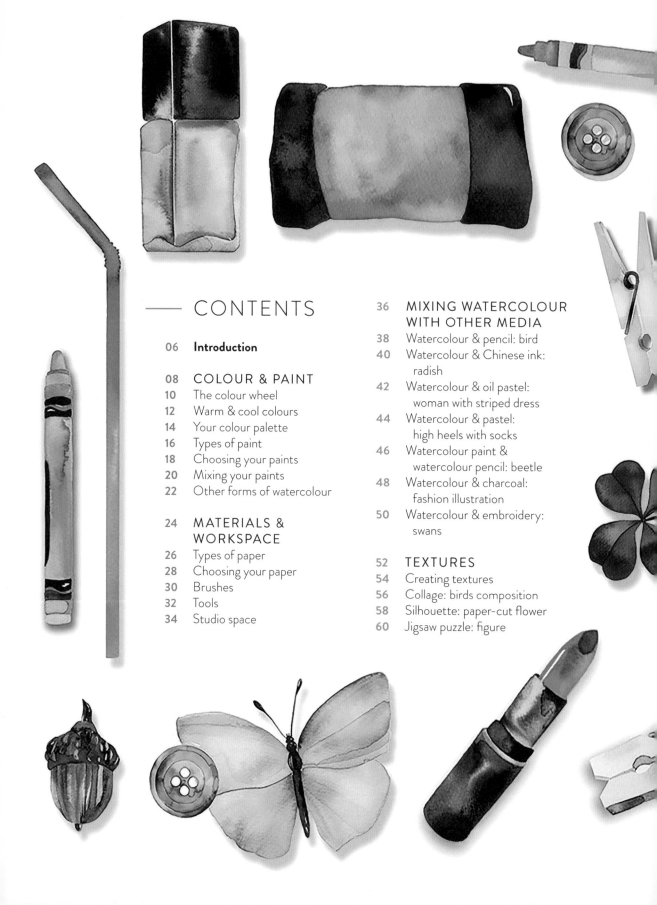

CONTENTS

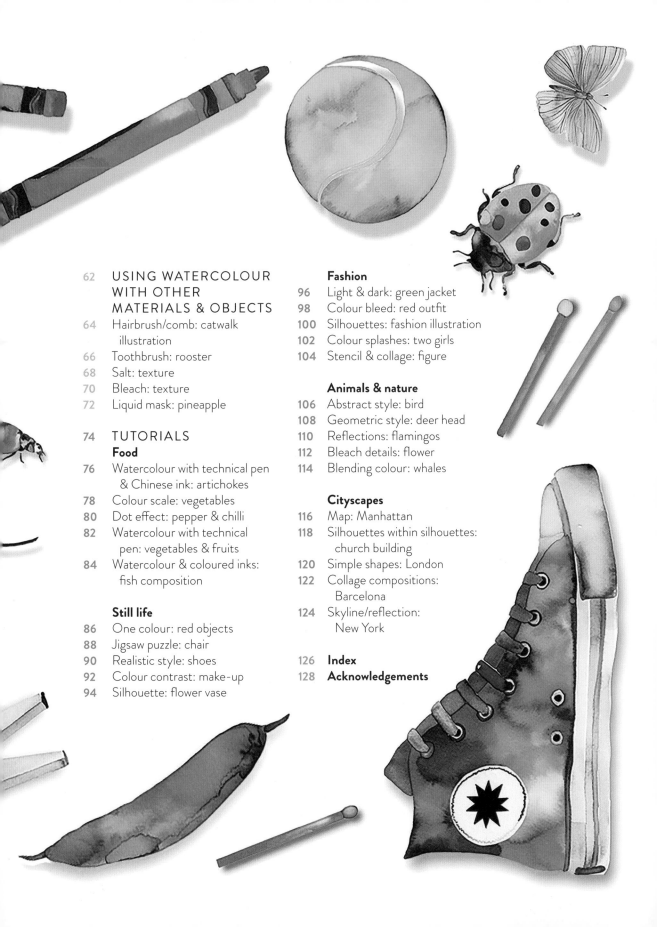

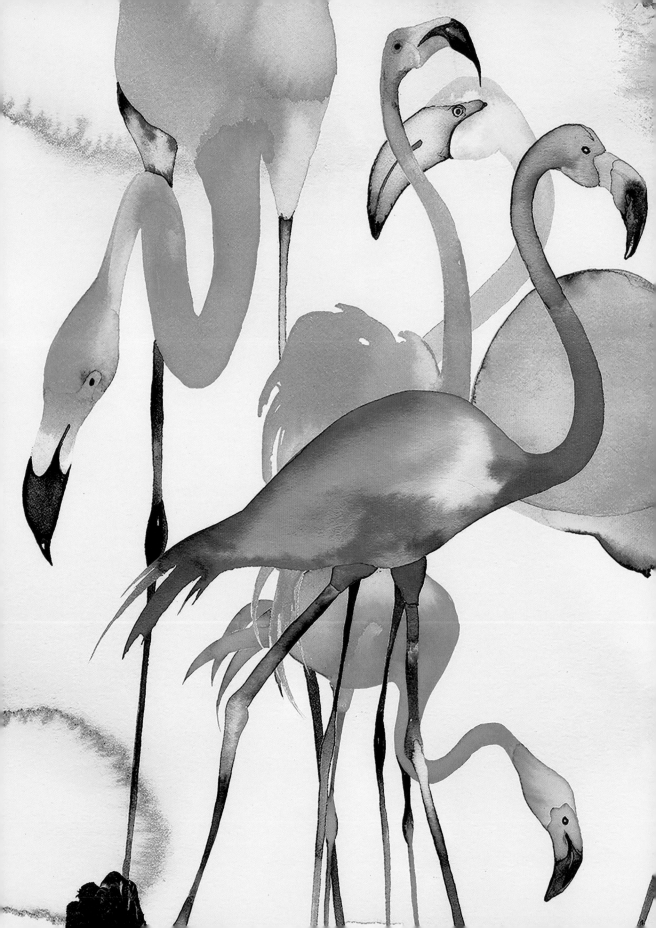

INTRODUCTION

As a professional illustrator, I work with lots of different techniques, but watercolour is by far my favourite medium. It's infinitely versatile - you can get endless colour variations, play with blending and transparencies, try out different types of paper, and mix it with other media to get really striking results. Innovation is the name of the game!

This is probably not the first idea that comes into your head when you think about watercolour painting. It's likely you consider it gentle, perhaps even staid and old-fashioned and most commonly used for landscapes and florals. But watercolour is undergoing a Renaissance. It's perfect to mix with ink, technical pen, pencil, charcoal or pastel, using watercolour as a contrast to the base illustration; you can also use it to create collages and silhouettes, or with stencils. You can be as bold as you like with your use of the paint, and create surprising compositions which, if you flick through the pages of this book, you will see are a far cry from most preconceptions about watercolour.

Perhaps what I love about watercolour the most is that it doesn't have to be perfect.

Perhaps what I love about watercolour the most is that it doesn't have to be perfect.

In fact, it can't be perfect. This encourages experimentation, and I'm excited by how it can be difficult to predict or control the results of what I'm working on. Every artwork created with watercolour is unique and, try as we may, getting the exact same effect a second time is pretty much impossible.

It's possibly this that's allowing watercolour to have its second life. Digital illustration is very popular and we can get fantastic results using technology. But even though we can create a watercolour-effect illustration using a computer, it's just not the same as a 'real' piece of artwork, with all its surprises and quirks, painted by hand on paper.

I'm often asked how I produce the effects in my artworks – people want me to teach them or let them come to my studio and see how it's done. Well, that's what I'm doing here. I invite you to follow the exercises in the book and put the techniques I use into practice. If you're a beginner, I'm thrilled to introduce you to my favourite medium and hope that I'm opening the door for you to a new world of pleasure and creativity; if you already paint with watercolours, then I hope you'll learn some new techniques, enhance your skills and find renewed inspiration.

In the following pages I'll show you some modern and graphic techniques, and also share my best tips and the many discoveries I've made over the years working with watercolour. You won't find anything too complicated here – my last word is to urge you to explore your own creativity and experiment for yourself. Don't worry about making mistakes – just have fun.

COLOUR & PAINT

The special quality of watercolour painting is its translucency. The colours in a watercolour work appear bright and luminous, and a huge range of effects can be achieved with this incredibly versatile medium.

Painting with watercolour is based on subtractive colour mixing. The pigments in solid and cream watercolours, and dyes in liquid watercolours, are materials that absorb or 'subtract' certain wavelengths of light, so instead of pure white, where a paint is applied, we see colour. There are hundreds of ways in which the primary colours – red, yellow, and blue – can be mixed together to produce a range of colours, and in theory, black is produced when we mix the three primary colours. In practice however, we usually use black paint if we want to paint something black as we get a stronger colour with a pure pigment or dye.

THE COLOUR WHEEL

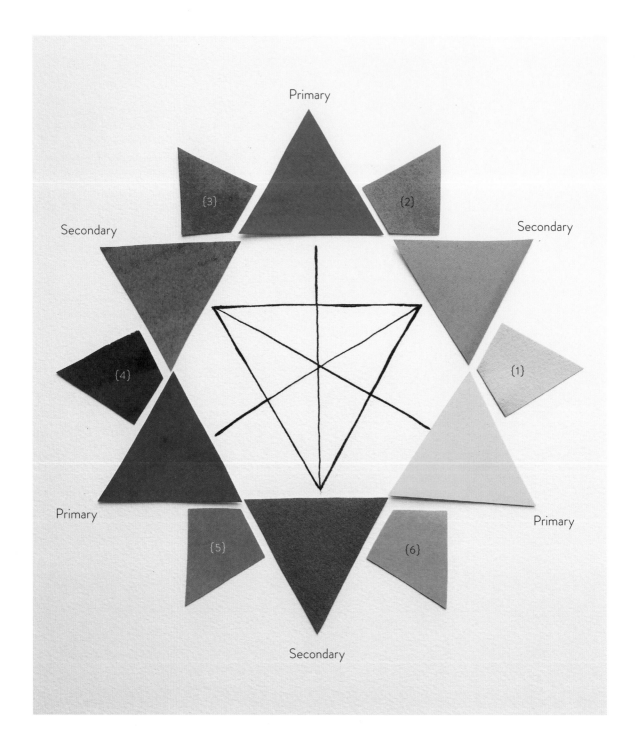

The three primary colours of the standard colour wheel are: red, yellow, blue. When two of the primary colours are mixed together, we get the secondary colours: green, purple, orange. Tertiary colours are produced by mixing a primary colour with the secondary colour 'next' to it, as you can see in the diagram opposite. The tertiary colours are: {1} Yellow-orange (amber), {2} Red-orange (vermilion), {3} Red-purple (magenta), {4} Blue-purple (violet), {5} Blue-green (teal), {6} Yellow-green (chartreuse).

The exact colour that you produce when you're painting will depend on which paints you start off with. For example, you would get a much softer green if you mixed Aureolin (Cobalt Yellow) with Cobalt Blue than if you mixed Winsor Yellow with Winsor Blue. And those two greens would be different from the green you'd get if you used a green pigment or dye to begin with, such as Viridian or Hooker's Green.

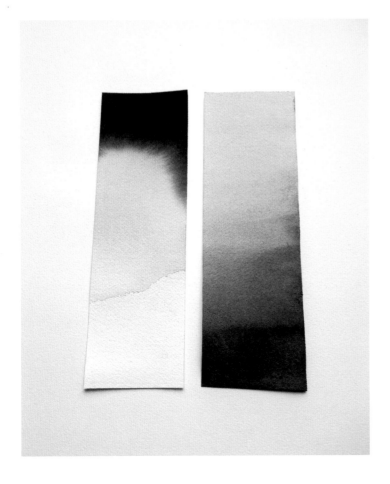

✳ TIP: You can create numerous variations of each colour you have just by adding white (or water), black or grey. To the left you can see two strips of paper showing different shades of grey from black to white. The strip on the left was made lighter by adding water, the strip on the right was made lighter by adding white.

WARM & COOL COLOURS

In colour theory we can divide the colour spectrum into warm and cool colours.

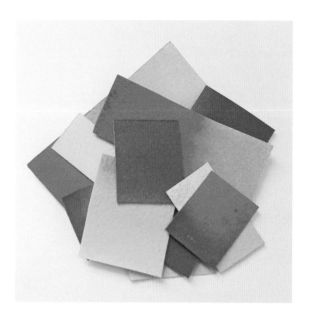

⇥ WARM COLOURS

Warm colours – or active colours – range from yellow and orange through to red, and also include brown and tan shades. Warm colours are associated with the sun, summer, earth, heat and fire. Shades of red are strong and effectively express passion, anger and dynamism in an illustration; orange is more suggestive of fire and autumn, and yellow has associations of sunlight and happiness.

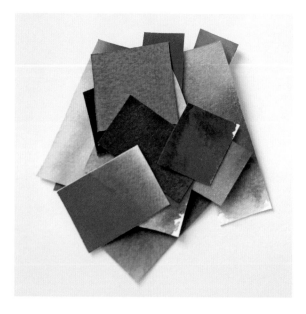

⇥ COOL COLOURS

Cool colours – passive colours – are purples, violets, blues and greens, and also the various shades of grey. Cool shades can be soothing and are often associated with relaxation and harmony; they can also remind us of the sky, winter, water and the moon. Green is the colour of nature and the environment, and purple has connotations of royalty, extravagance and individualism; I particularly like using purple mixed with warm colours such as red and orange to create contrast in sunset or summer night-sky effects.

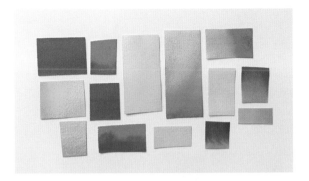

* TIP: You can completely change the mood of a piece through your choice of colours. Above are two images, one painted using warm colours and the other with cool colours, giving a lively feel to the left, and more subdued feel to the right respectively.

YOUR COLOUR PALETTE

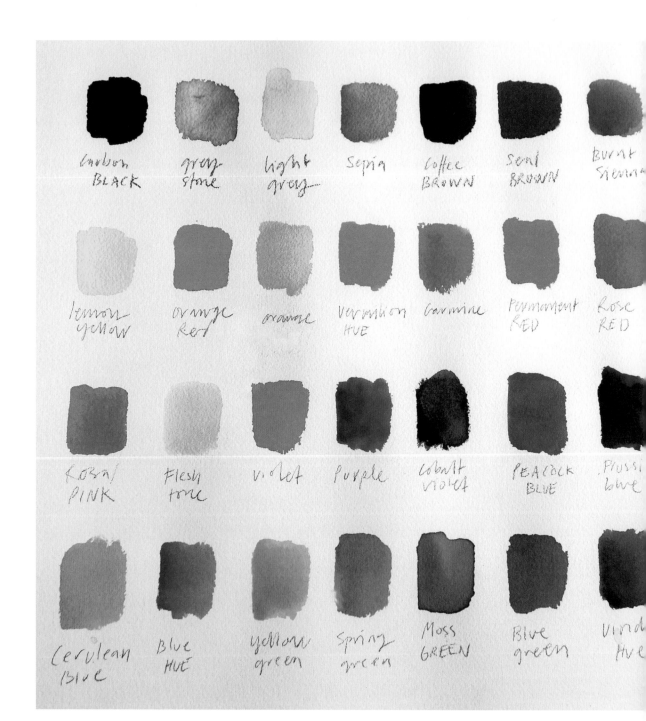

carbon BLACK · gray stone · light grey · Sepia · Coffee BROWN · Seal BROWN · Burnt Sienna

lemon yellow · orange Red · orange · Vermilion HUE · Carmine · Permanent RED · Rose RED

ROSA/ PINK · Flesh tone · violet · Purple · Cobalt violet · PEACOCK BLUE · Prussian blue

Cerulean Blue · Blue HUE · Yellow green · Spring green · Moss GREEN · Blue green · Viridian HUE

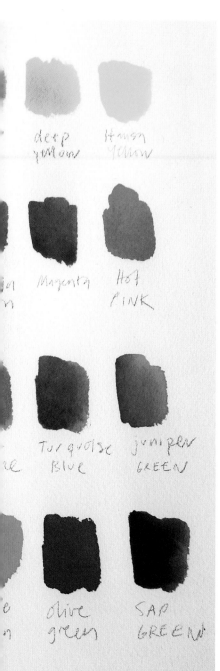

deep yellow

Honey yellow

Magenta

Hot PINK

Turquoise Blue

juniper GREEN

olive green

SAP GREEN

These days there are around 120 different watercolour pigments available and also dozens of different liquid watercolour shades of dye.

You don't need to buy all the colours! With one pure colour alone you can get up to 15 variations, depending on the amount of water you use, and then you also have the many colour variations you can create by combining the colours together in their different quantities.

When you buy solid watercolours as a set you will usually get a basic selection of, say, 12 colours. These won't usually include black and white, and you may want to add at least a few more extra colours to the selection, as while technically you can make every colour you could want by mixing just the primary ones, you'll find you get a more intense colour by using a single pigment (and likewise, dye, for liquid watercolours). You can make up your palette with as many different colours as you like, or as few; it's entirely up to you.

Personally, I like to have a wide selection of colours to hand because that way I have more choice to begin with when I'm deciding on the colour scheme of a work. The colours you choose come down to your own personal preferences, and every artist has their own preferred pigments and choices of liquid paint colours.

⤑ STARTER SELECTION

My recommendation for starting out would be to make up your palette with the following:

Black, white, two different reds, two yellows, two oranges, two browns, two greys, two greens, two blues, two violets and two pinks.

In the image to the left, you can see the names of the paint colours that I use the most as my selection of 40 (not including white).

TYPES OF PAINT

There are three main types of watercolour paint: solid, liquid and cream.

≫→ SOLID

The solid format of watercolour paint is the traditional form. These are made from pigments mixed with a water-soluble binder (usually gum arabic), which fixes them on to the paper. They are applied with water, and when the water evaporates, the pigment remains.

Solid watercolours come either in small plastic boxes (pans) or wrapped in paper, and you can buy a set of colours or each colour separately. Pans of watercolour paint are hard and dry and you need to wet them with a brush to use them. They give a more opaque result than when using liquids, and are better for more detailed illustrations, rather than abstract ones. They also last longer than liquid watercolours as you don't use as much of the medium.

≫→ LIQUID

Concentrated liquid watercolours are generally made with dye rather than traditional pigments, and are absorbed by the paper instead of adhering to its surface. Liquid watercolours are concentrated so the colours they produce are dazzlingly rich and vibrant. They can be used full strength or diluted, depending on how strong you want the colour.

Liquid watercolours come in small glass or plastic bottles, and depending on the brand, may have a pipette incorporated into the lid of the bottle, which is great for creating splash effects and textures.

≫→ CREAM

You can also buy tubes of pigment-based watercolour paint, which are creamy in texture. Tubes are great for mixing colours but you use more paint than with pans, which can make them more expensive. It's also less easy to re-activate them with water if they dry out on your palette.

You can create textures and expressive effects with creams that you can't get from using pans or liquids, by applying the paint directly on to the paper and smearing it to get the effect that you want. It's also more versatile as a form – you can achieve a very transparent effect when mixing it with a lot of water or a more opaque effect by using only a small amount of water.

* **TIP: To keep paints in good condition after use, close them in their original bottles, tubes or containers, and keep them away from the sun.**

CHOOSING YOUR PAINTS

As well as colour and type, there are also a number of other elements that you might want to consider when you're buying and choosing your paints.

⇻ GRADE

First of all there's the question of whether you should use 'student'- or 'artist'-grade paints. (This applies to pigment-based solid and cream watercolour paints rather than the liquid ones.) If you're starting out with watercolour, you may wish to choose 'student'- or 'academic'-grade paints until you really get going, rather than 'artist'-quality, as there is a significant difference in price.

But while 'student'-quality is less expensive, 'artist'-quality gives you the highest concentration of pigment and therefore much more intense colours, and there is also a wider choice of colours to choose from. You may therefore feel it's worth jumping straight into the better-quality level of the medium. You will notice that 'artist'-quality paints are further divided into 'series' (A, B, or 1, 2, depending on the brand); it's the higher letter or number that's the more expensive.

⇾ COLOUR NAME

When you see a paint labelled 'hue' (for example, 'Cadmium red hue') this means it's not the original pure pigment or dye but a combination of less expensive materials that gives a similar colour. Using a 'hue' rather than the pure pigment or dye is more affordable, but it won't give you as good colour intensity.

You'll also see several different brands offering colours with the same names; be aware that the colour might come out slightly differently from brand to brand and the intensity of the colour may vary too.

⇾ PERMANENCE

The packaging will indicate the permanence or 'lightfastness' of the paint; if you're not just practising with different techniques, you'll want your works to endure, so be sure to choose paints that are indicated as having a high level of permanence.

In experimenting with them over the years, I have found that the more expensive paints often give the best results, but it also depends on the choice of paper, paint and tools together. It's all about the combination, and the easiest way to find out the best one is to try it out!

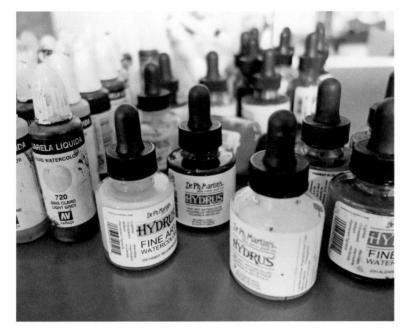

* **TIP: You can make watercolour paint more transparent by adding water to it, but this will diminish the vibrancy of the colour.**

MIXING YOUR PAINTS

To use solid and cream watercolour paints you dilute the paint by mixing it with clean water on your palette, using your brush; how much water you mix in with it determines how strong the colour will be. Liquid watercolours you can dilute or not, as you wish.

I feel it's easier to mix liquid watercolours than solid ones as you have more control over the density of the colour; it's also easier to keep liquid and cream paints clean, as you have to wet pans of solid paint with your brush to release the colour.

Before starting a watercolour illustration, you'll want to get your colour palette organized and your colours mixed in advance, especially if you are working on a project across several days. It can be difficult to match the shades if you have to mix them again, and you want to be able to keep the colours consistent. Of course there's always the option of retouching your illustration digitally using Photoshop, but it makes better sense to have your colours as you want them to begin with, rather than spending time editing them on the computer afterwards.

You need to know the basic rules of colour mixing using a colour wheel (see page 10), but I find the best way of mixing colours is simply to experiment. However, an easy mistake to make is to add black to make a colour darker, when actually this will change the colour completely. It's much more effective to use more of the same colour to get a darker and more intense shade.

Adding white and lots of water gives a lighter colour, but be careful as adding white to coloured paints also makes them opaque. Many watercolourists, especially more traditional ones, prefer to use just the white of the paper; I use opaque white watercolour paint for gloss and to add fine details on top of other colours.

I recommend mixing your colours in a space with good light, if possible natural light. Be aware that, as the light changes during the day, the appearance of the colour you are mixing may also change. Another thing to bear in mind is that the colour will be lighter when the paint dries than when you first applied it to the paper. Test colours out if necessary before you begin your artwork.

> I recommend mixing your colours in a space with good light, if possible natural light.

*** TIP:** When mixing the paints together to get the colours you need, you'll probably want to check out how the colour looks on a piece of scrap paper. That way you'll see how the colour looks on paper and whether the colour is dense enough.

*** TIP:** If your solid paints have become dirty, you can wipe them gently with a moist paper towel. The colour underneath will still be pure.

*** TIP:** I prefer my palette more used and 'dirty' as this produces lots of tones. This is very good for creating textures and for less clean-cut illustrations, such as more realistic images of people, animals and nature.

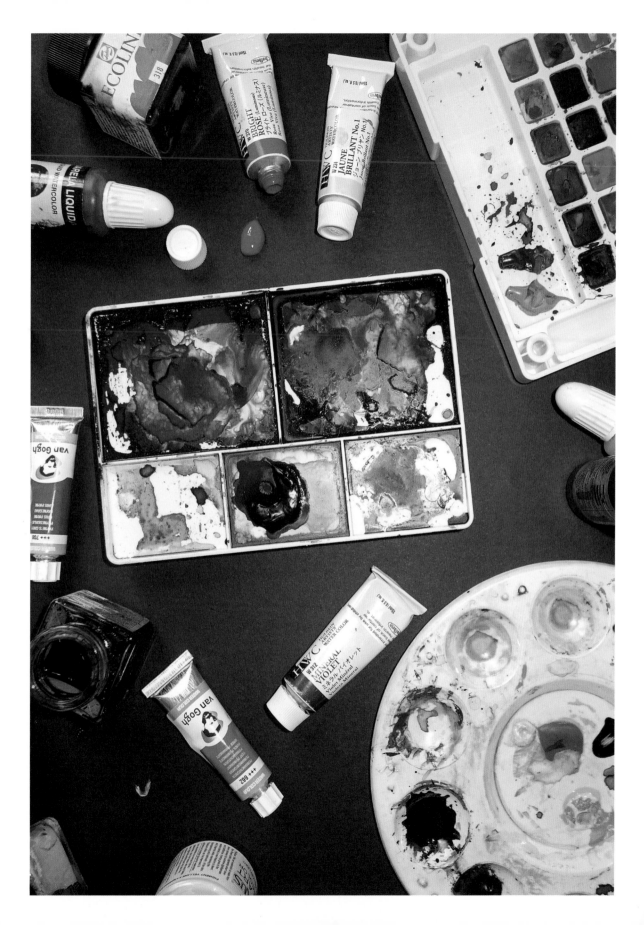

OTHER FORMS OF
WATERCOLOUR

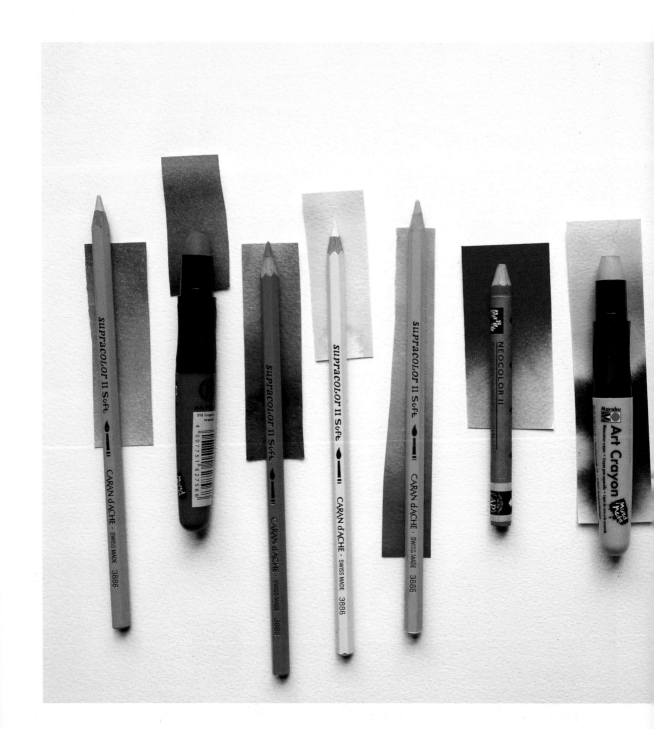

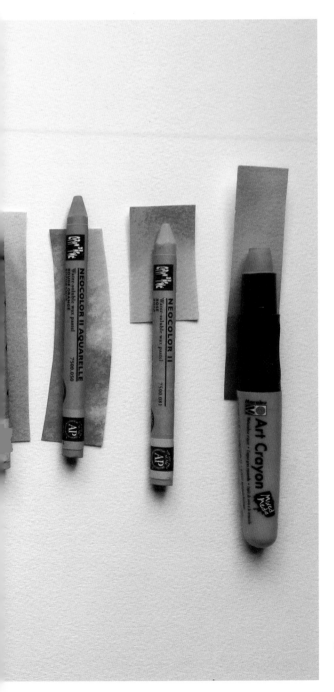

Watercolour doesn't just stop with the paints. As well as pans, tubes and liquids, you can also get watercolour pencils, pens or markers, and sticks.

Watercolour pencils have water-soluble lead. They're great to use in conjunction with paint as you can add fine details that it would be difficult to do with a brush. You can either leave the drawing as it is, as it would be with a normal pencil, or apply water with a brush to release the colour and blend the strokes and colours.

Watercolour pens are a new innovation and they're great for quick sketches. As with the pencils, you can add water with a brush and blend the strokes; they're available with a marker-style nib in various thicknesses, or with a brush-style tip.

Watercolour sticks are rather like pastels in that they have a square tip that allows you to create a variety of different line widths. You can apply them to wet or dry paper, and create all kinds of distinctive effects: you can let the lines you've drawn bleed into a wash, apply crosshatching or play around with various textures as background washes.

✳ **TIP: These alternative watercolour media are all completely mixable with watercolour paints.**

MATERIALS & WORKSPACE

You don't need more than a few basic tools and materials to get started with creating amazing watercolour artworks.

Here I will go through the essentials that I regularly use in my work, and you will find with experience which types you prefer to use, that allow you to be as imaginative and experimental as you want. If you also set up your workspace so that it's comfortable and practical, it will allow your creativity to flourish and you to fulfil your artistic potential to the max.

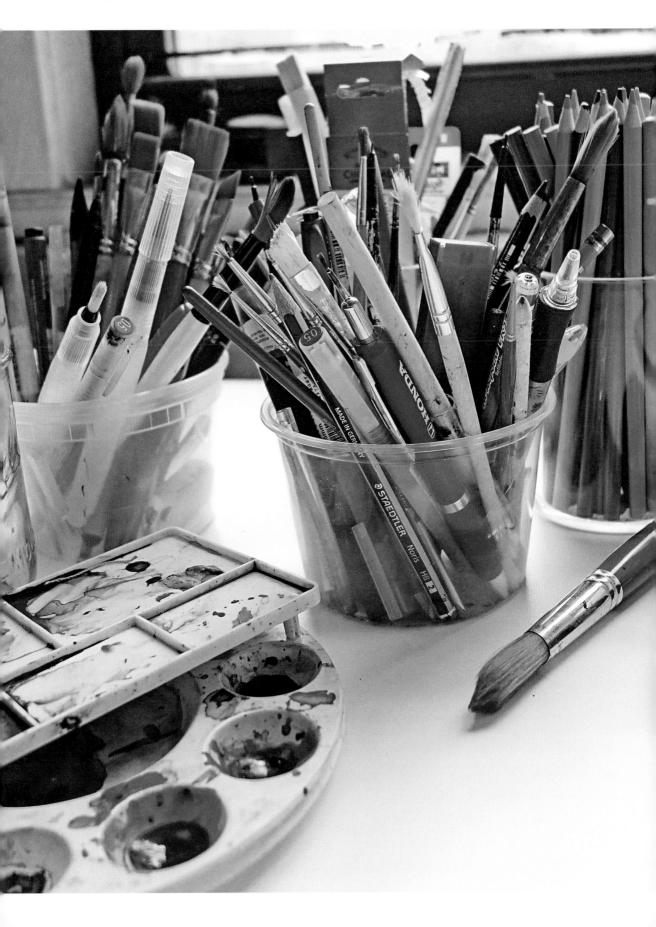

TYPES OF PAPER

It's important that you use paper that is specifically produced for watercolour. Other types of paper will be no good - they will either buckle immediately, the surface may be spoiled or they will be so absorbent that the paint will sink into it entirely.

Watercolour paper comes with a coating or 'sizing' of gelatin on its surface, which means that paint isn't absorbed straight into it, instead remaining largely on the surface of the paper so that colours stay vivid and don't bleed into it.

Paper is classified according to its weight, which is in effect its thickness, and is referred to in terms of 'gsm' (grams per square metre for one sheet of paper). 300 gsm is the most commonly used weight of paper for watercolour as it's suitable for most of the techniques you're likely to be using. If you intend to paint with a lot of water, however, you'll want to use a heavier weight such as 620 gsm. Paper of less than 200 gsm isn't advisable for your watercolour works; your illustration will be ruined as soon as you start applying any significant amount of paint and water.

Watercolour paper is made in three different ways: handmade, mould-made or machine-made. Handmade is the best, with mould-made coming second in quality. 'Artist'-quality paper will be handmade or mould-made. 'Student'-quality paper is usually machine-made, and is very prone to buckling when wet.

➤ HANDMADE

The quality and character of handmade paper is what makes it unique. It's made from textile fibres (you may see it labelled '100% cotton rag'); the textile fibres provide a balanced absorbency, which means the paper won't buckle when you apply water. It lasts for years, as the paper is free from acid, and has a lovely irregular quality in its texture. Handmade paper is expensive but you'll find it's certainly worth it if you're creating a special piece.

➤ MOULD-MADE

Mould-made paper is a bit more uniform than handmade paper, but it's also very durable and won't buckle with a lot of water.

➤ MACHINE-MADE

Machine-made paper is more reasonable in price and it's most likely what you'll be using most of the time, but it's more regular in texture and therefore has less character. It's also less durable, being made from paper fibres or sometimes wood pulp rather than cotton, and may yellow over time because of its acidic content.

✻ **TIP: Most papers can be used with watercolour on both sides, but the top tends to be grainier than the underside. I prefer using the more textured side as it's easier to control the water and colour.**

CHOOSING YOUR PAPER

There is a huge variety of paper - different brands, types, weights, sizes, rolls and blocks - available for you to use for your watercolour artworks and the choice may be bewildering. Choosing the right paper for your creations is almost as important as choosing the right paints!

You can buy watercolour paper in rolls, pads, blocks or individual sheets. Individual sheets are great for testing out different papers before you buy a larger quantity. (Check individual sheets for cleanliness though; it's impossible to remove fingerprints from paper and they can show up later through your paint.)

If you know you're going to use a lot of a certain type of paper, it will be the most economic option to purchase a roll and cut it yourself. However, spiral-bound pads are good for travelling and blocks are practical as the cardboard base provides a support. For blocks, the fact that the paper is stuck down on all sides can also help minimize buckling and it's handy to be able to tear off the top sheet if you want to begin another painting before it's dry.

As with different paints and colours, the best thing to do is test out several papers so you can establish which will work best for the project you are about to embark on. Paper ranges in quality, and the quality is reflected in the price. Watercolour paper is in general quite expensive, so I recommend you use cheaper paper – 'student'- or 'sketch'-grade – for sketches and experiments, and good-quality paper – 'artist quality'- or 'fine art'-paper – for your final artworks.

With the high quality of paper on the market today, I find I don't need to use the traditional technique of 'stretching' paper to stop it buckling. This might mean investing in some more expensive paper, but saves a lot of time in the long run.

* **TIP: If you're buying cheap paper, check the label first to see if it's acid free – you don't want your artwork to deteriorate quickly because of the acidic paper.**

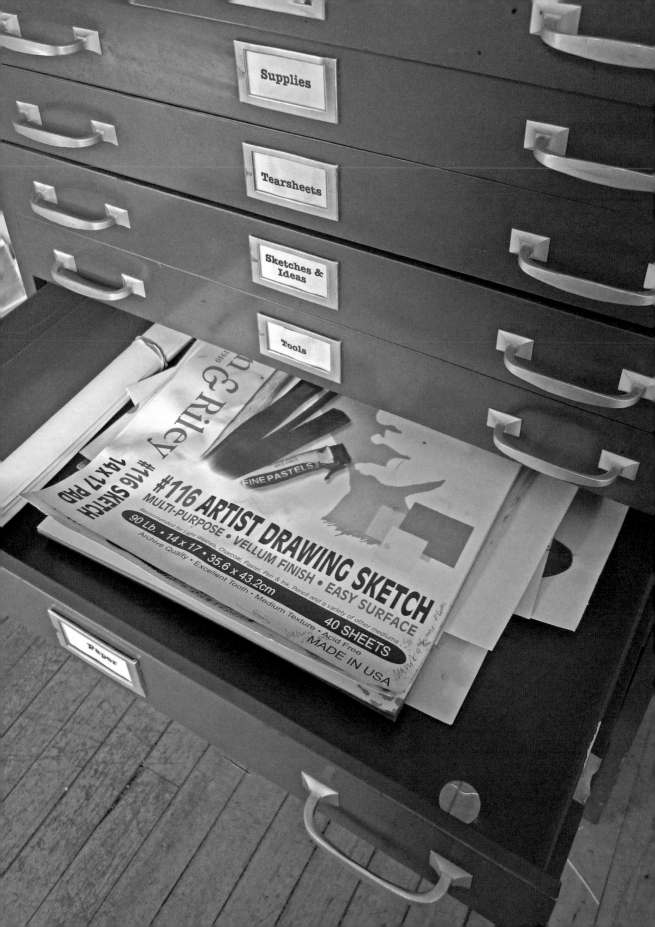

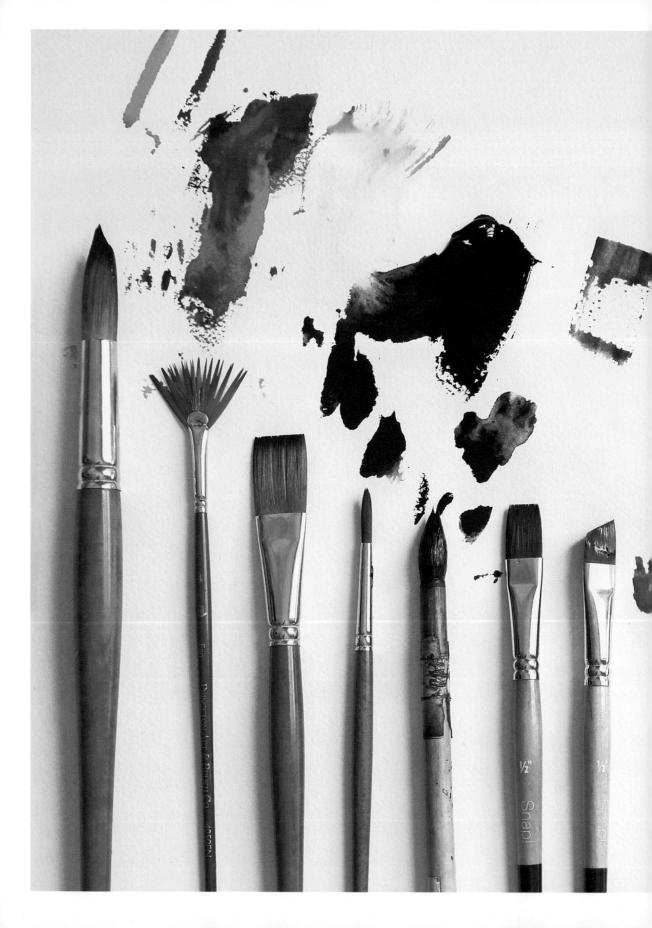

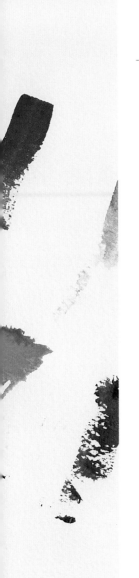

BRUSHES

Brushes are the most commonly used tools for painting and there's a huge variety available in terms of quality, price, size and type of hair.

Watercolour brushes can be synthetic or natural. The natural ones use hair from squirrels, sables and martens, and are better than synthetic brushes for absorbing water and paint. Natural brushes are also nicely elastic and form a good tip for painting with, as well as having better durability – I've been working with some of my best ones for years.

Large, flat brushes are good for backgrounds and broad areas, and they absorb a lot of water, making them good to use for washes, whereas smaller brushes are better for details: faces, animals and objects. As you can see from the image to the left, brushes also come in many different shapes including flat, round, and fan shapes, and these can be used to achieve all kinds of effects. Predictably, the best-quality brushes are those that are the most expensive, but you can use some brushes for multiple purposes, and will soon work out which are best for a task and which are your favourites.

* **TIP:** It's important to keep brushes clean and dry. After use, clean them with water and a little bit of soap, let them dry and put them away – this will help them last longer.

* **TIP:** You can use your watercolour brushes for other water-soluble media, such as gouache and ink, but don't use them with oil paints and acrylic paints.

TOOLS

As well as brushes, you'll also need a variety of other tools to make your artworks.

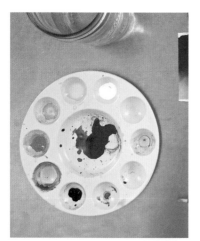

➤ MIXING PALETTES

These can come in a variety of materials including plastic, porcelain and metal, or you can simply use a plain white dinner plate!

➤ CUPS

You'll also need some different plastic or glass cups to hold the water you're painting with and to clean your brushes. Note that some artists prefer to use distilled water, but I find that tap water is fine.

➤ PENCILS

You'll need pencils for marking outlines and erasers for rubbing them out and generally tidying up where pencil lines are visible. (And of course a sharpener, too.)

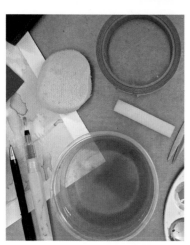

➤ ADHESIVE TAPE

You'll need tape to fix your paper on to the table.

➤ SCALPEL OR CUTTER

These are great for cutting paper – better than scissors as you can cut curves, details and silhouettes more precisely. You'll also need to use a scalpel to create your stencils.

➤ SPONGES

Sponges are incredibly useful. I love using them to moisten the paper and to add texture to artworks. You can make interesting textures by moistening paper with a very diluted colour using the sponge and by using the sponge like a stamp; with several different colours together you can achieve some great painterly effects. A sponge can also be used to remove or clarify parts of a piece once you've created it, as long as the paper is still damp.

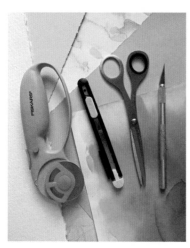

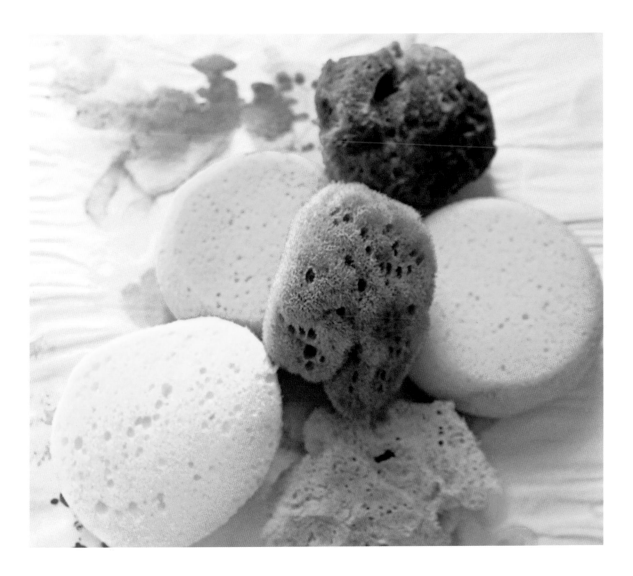

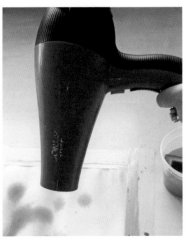

➤ HAIRDRYER

You don't have to, but you can use a hairdryer to speed up the drying process of your works, which can be useful when you're working with a wet background, for example, and don't want to have to wait. You can also achieve interesting effects using a hairdryer to blow paint or bleach, as you'll see on pages 54 and 71.

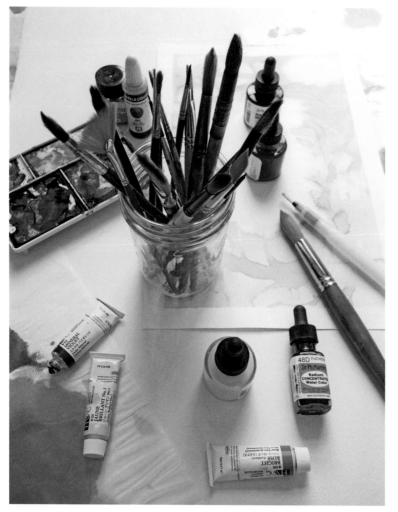

— STUDIO
SPACE

Whether you're a professional or an amateur enthusiast, the place where you create your artworks is important - you need to be in a place where you feel good and inspiration flows.

Most illustrators like myself work as freelancers, and while some have a workspace at home, I prefer to have a studio where I can go to work. I share a big studio in Brooklyn, New York, which is where I'm based; this works brilliantly because, while I'd otherwise work entirely alone, communicating with my clients for the most part via email or phone, in the studio I get to share ideas with other creatives. Keeping work and home life separate is also my preference.

On a practical level you need to have a space where you can work comfortably and organize your tools, materials, equipment and works, and it makes sense to have a place where you can leave a project you're working on where it's not going to be disturbed.

Your workspace needs to be well lit - ideally with big windows, giving you an abundance of natural light, as well as with good sources of artificial lighting. You should also allow yourself plenty of table space if possible – my recommendation is that you have one big table for your computer, scanner and printer (if you use these for editing and digital work) and another for drawing and painting. That way you can be sure you don't accidentally tip your paint water over your expensive technology.

You'll work more efficiently if you keep your surfaces uncluttered and organize your materials and tools in boxes or on shelves. A storage system for your papers, sketches and finished artworks is also a good idea so that you can find things easily and keep your artworks safe. Some kind of cupboard with drawers is ideal; I use a big filing cabinet and consider it to be one of the best investments I have made for my work – after all, I've poured hours of hard work into my pieces, so they deserve to be looked after!

≫→ HERE'S MY LIST OF THINGS YOU MIGHT WANT TO INCLUDE WHEN YOU'RE SETTING UP YOUR STUDIO SPACE:

- a drawing and painting table

- a separate table for your computer and other technical gear

- boxes and shelves for organizing your materials and tools

- a cutting mat for cutting paper with a scalpel or cutter

- computer, scanner and printer

- a lightbox (this is useful for tracing)

- a filing cabinet or other drawer system for storing paper and finished work

- good lighting (essential)

MIXING WATERCOLOUR WITH OTHER MEDIA

You can create some fabulously unique and distinctive works by combining watercolour with other media such as watercolour pencil, technical pen, Chinese ink, pastel or oil pastel. This is a way of making your illustrations really stand out.

Go ahead and experiment with other media to see what effects you can achieve – see if you can come up with some great combinations that make your artworks entirely original. The only media I don't advise you try in this context are oil paints and acrylic paints, as they don't work well with watercolour.

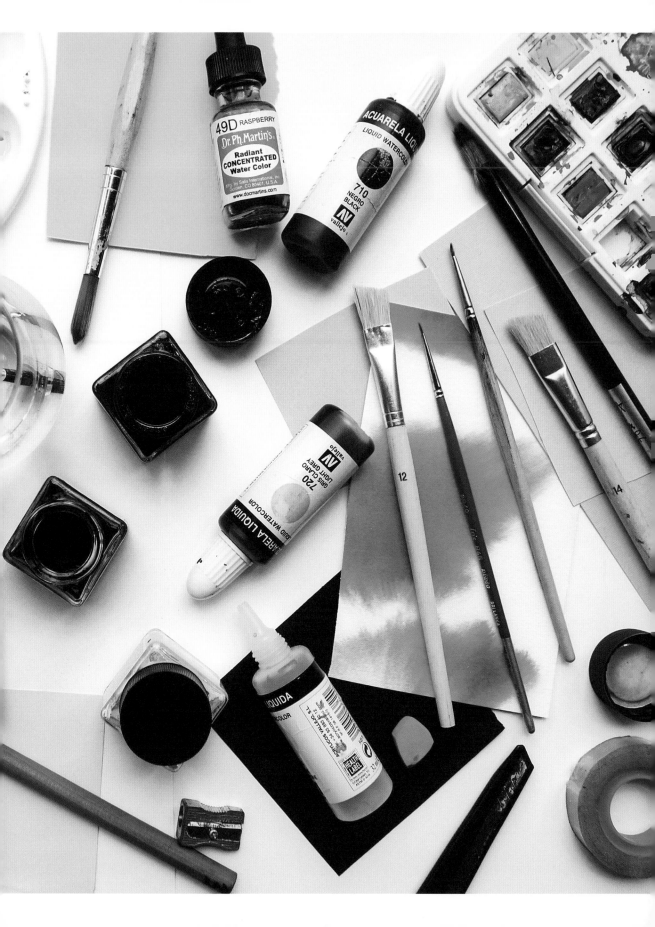

WATERCOLOUR & PENCIL

We often use pencil with watercolour painting. In fact, it's probably the most common 'mixed media' combination as we usually sketch out the outlines of our subject matter in pencil before we begin adding colour, and also use it to add details.

With the technique shown here, that combines a pencil drawing with loose splashes of watercolour that go over the lines instead of staying within them, rather than using watercolour to add colour to the pencil drawing in the traditional, conventional way, we can create an illustration that is beautiful, fresh looking and full of personality.

WATERCOLOUR & PENCIL: BIRD

{1} Draw the outlines of the bird in pencil. Add highlights, shadows and details to your drawing to make it look more realistic. {2} Prepare the colours you're going to use on the bird. Start applying the paint over the drawing with your brush. Don't fill in the drawing tidily, but use brushstrokes to apply shapes of colour, creating a looser style that goes over the pencil lines. {3} Use different sizes of brush to create varying sizes of brushstroke, and allow colours to overlap now and again.

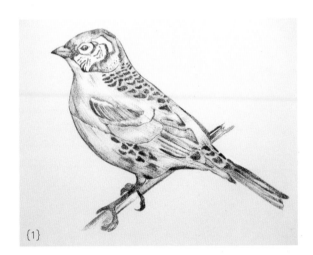

{1}

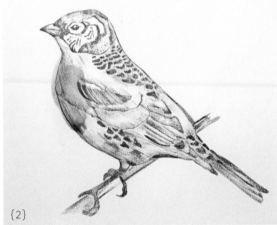

{2}

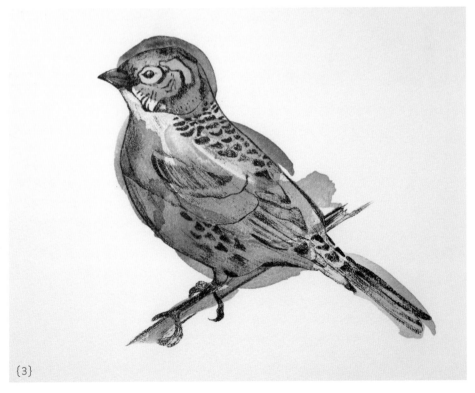

{3}

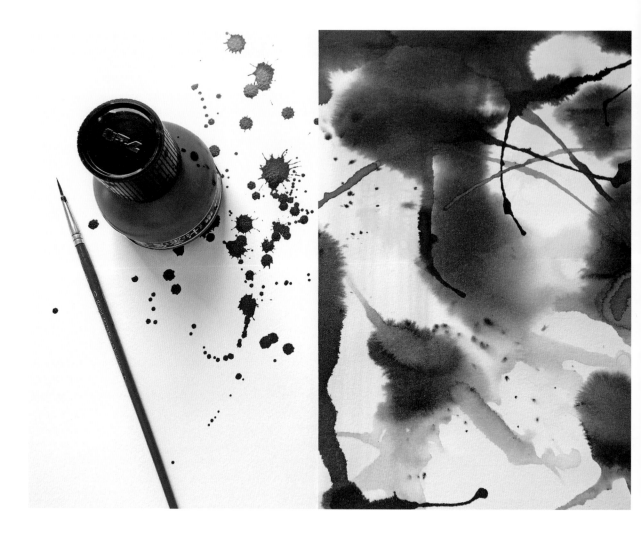

WATERCOLOUR
& CHINESE INK

Chinese ink is the medium used in traditional Chinese calligraphy and it works particularly well with watercolour.

Chinese ink's consistency is much thicker than black watercolour paint, but what makes it really useful for mixed media use with watercolour is that, unlike other inks, it's waterproof. This means you can apply your paint over it and it will not smudge – making it the perfect medium to use to create illustrations that use black outlines, like the one I show you here.

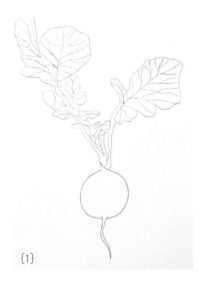

{1}

{2}

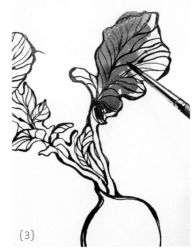

{3}

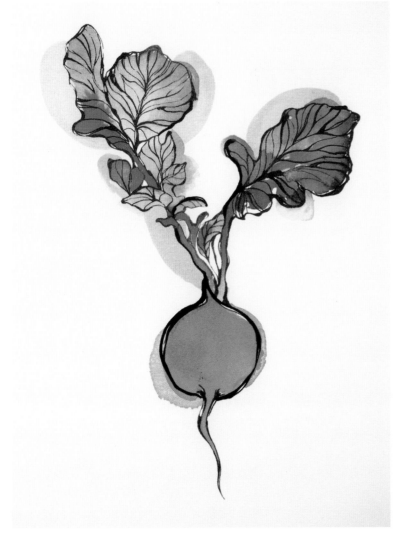

WATERCOLOUR & CHINESE INK: RADISH

{1} Draw the outlines of the radish in pencil. {2} Go over your outlines using Chinese ink with a very thin brush. The outlines don't have to be perfectly neat; keep them slightly irregular, varying the width of the lines to add texture. You can see I've used a thicker width for the main outlines, whereas the veins on the leaves are thinner. {3} Leave the ink to dry for at least an hour. It needs to be really dry for you to add the watercolour without it smudging. While the ink is drying, get your watercolours ready. Choose different shades of colour – here I have used several shades of green on the leaves. Then paint the radish with a small brush; apply the colour slightly outside the outlines to create a casual effect.

WATERCOLOUR & OIL PASTEL

Oil pastels are available in a wide range of colours, and they're a brilliant medium for adding texture to more abstract illustrations that don't require much detail, such as clothing, animals and plants.

Here the curves of the stripes drawn in oil pastel add a sense of movement to the garment, and the contrast with the watercolour makes for a striking illustration.

WATERCOLOUR & OIL
PASTEL: WOMAN WITH
STRIPED DRESS

{1} Draw the outlines in pencil. {2} Paint the base colours for the woman's skin, hair and face with your watercolours using a small brush. Let this layer dry. {3} Add the details for the skin, hair and face on top of the base colours using a small, fine brush. Let the illustration dry again. {4} Draw in the pattern of the dress with your oil pastels. It's impossible to be very accurate with them so don't worry if the lines are a little rough – the contrast in style and the texture is the whole point.

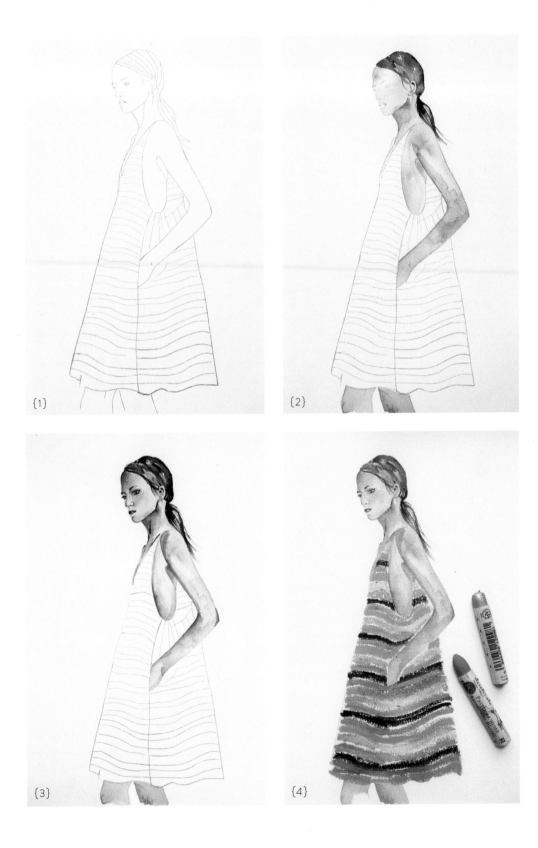

{1}

{2}

{3}

{4}

WATERCOLOUR
& PASTEL

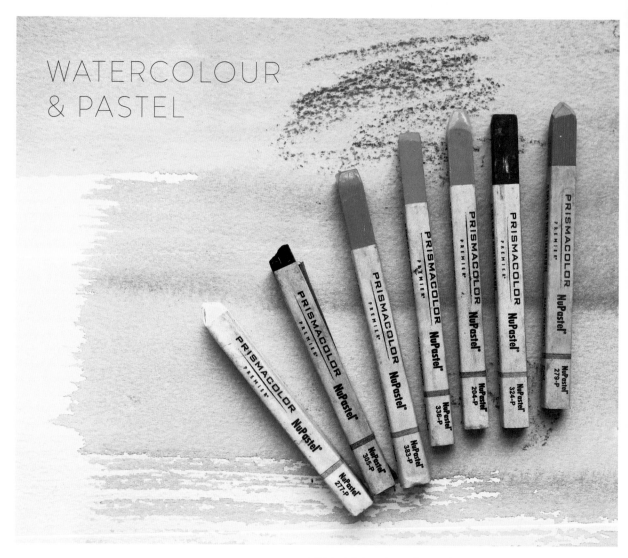

Pastels are great for blending and they also work well in contrast to watercolour. You wouldn't use them for small details, but they're ideal for sweeping, smudgy strokes, which give a sense of depth and add texture to an illustration.

As you can see here, the combination can look really original, and the contrast between the textures of the socks and the shoes is highly effective.

WATERCOLOUR & PASTEL: HIGH HEELS WITH SOCKS

{1} Draw the outlines in pencil. {2} Paint the legs, shoes and skirt with your watercolours, leaving the socks and one band of the skirt blank so you can add the pastel later – I've used a lot of water to create variation in the paint colour. {3} Add definition to the shoes and skirt in black using a fine brush. Let the paint dry. Use pastel to colour the stripes of the socks and the band of the skirt. You won't manage to be precise with the pastels, but don't worry as the smudgy look is what you're after. Protect your finished artwork with another sheet of paper on top, but don't fix it using normal pastel fixative, because this will ruin the watercolour.

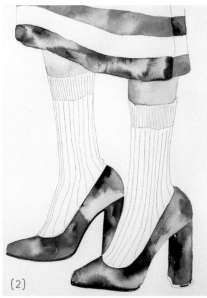

{1}

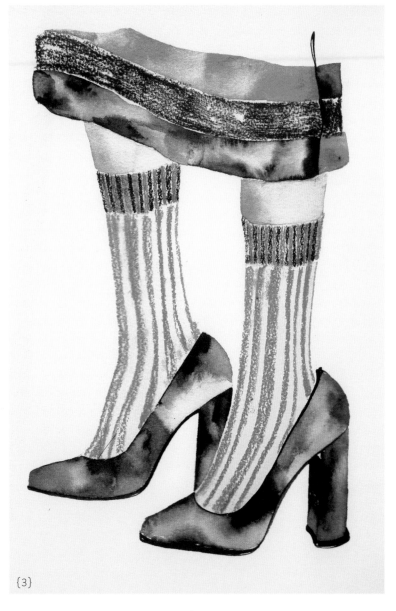

{3}

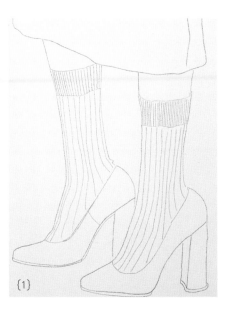

{2}

WATERCOLOUR PAINT & WATERCOLOUR PENCIL

Watercolour pencils are useful for more detailed illustrations as they allow for more precision than you can get with a brush.

Watercolour pencils can be used dry, or you can mix them with water to achieve a blended effect; just add water with a brush, using the tip, and work out the colour from the pencil strokes you've drawn.

With this example you can choose to keep your pencil strokes dry or add water and blend them – whichever you feel like doing.

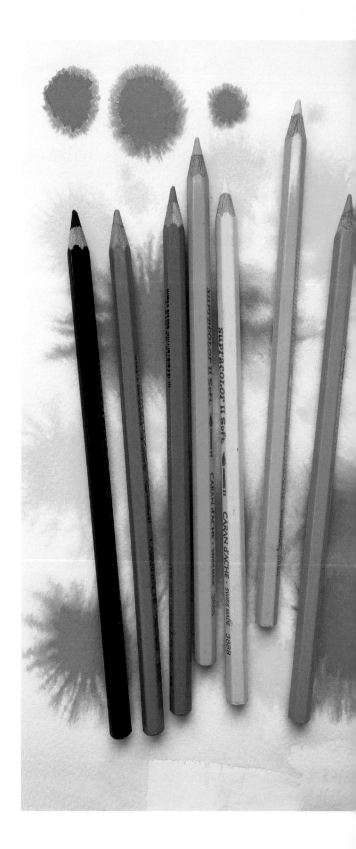

WATERCOLOUR PAINT & WATERCOLOUR PENCIL: BEETLE

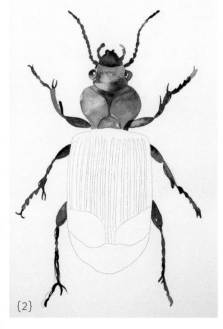

{1}

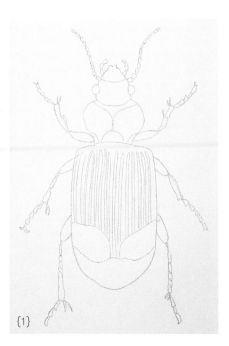

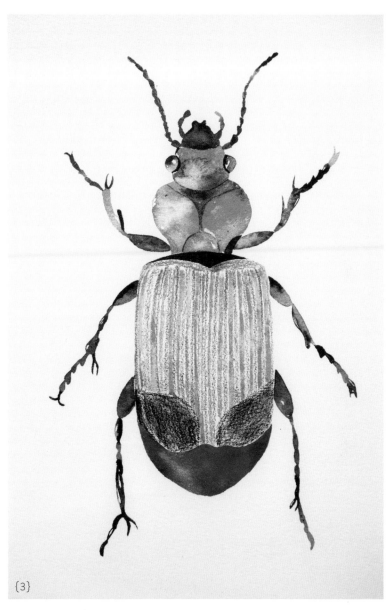

{2}

{3}

{1} Mark the outline and parts of the beetle in pencil. {2} Paint the beetle using watercolour paint but leave its main shell blank. {3} Let the paint dry. Use watercolour pencil to colour the stripes on the shell. You can leave the pencil work as it is so that it contrasts with the darker painted areas, as you can see here. Or you can add some water and blend the pencil. Finally, add some darker details with paint to the shell to make it more distinct.

WATERCOLOUR & CHARCOAL

Charcoal can be used with watercolour to make really bold, dynamic and vibrant artworks; I love the way the graininess of the charcoal strokes contrasts with the fluid, smooth contours of the paint. As with pastel, you wouldn't choose to use charcoal for precise line work, but it's perfect for a sketchy, sweeping style – you'll find that it's very versatile as a medium because you can create darker or lighter shades depending on how much pressure you apply, and can also use it for subtle shading.

Here I'm using thin- and medium-thickness charcoal pencils and a charcoal stick. Use watercolour paper as it could potentially be quite wet, and for this illustration I would also recommend liquid or tube watercolour for the most vibrant colours possible.

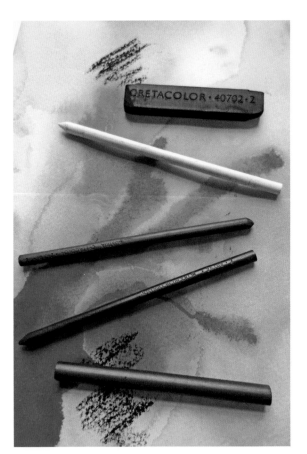

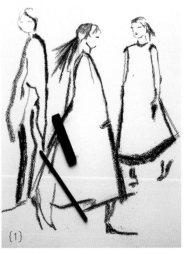

{1}

{1} Draw out the outlines of the girls in charcoal. Use big, loose strokes because you want as much of a sense of movement in the illustration as possible.

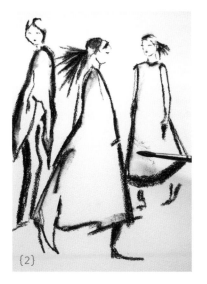

{2}

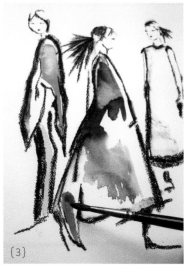

{3}

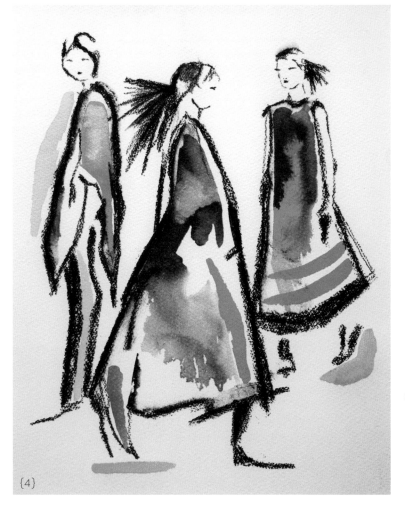

{4}

WATERCOLOUR & CHARCOAL: FASHION ILLUSTRATION

{2} When you've finished drawing, take a wet brush and moisten some of the lines to get a lightly smudgy effect. {3} Wait for it to dry and prepare your paints. Apply the paint, keeping your strokes within the outlines, but not filling the different areas completely with colour – strokes of colour with an abstract effect is the look you're after. Be careful to keep your brush away from the charcoal lines so that you don't smudge them further. {4} Add a few strokes of contrasting colour paint to give the impression of pattern and movement to the garments. Finish off by painting a couple of lines on the ground underneath the figures to root them.

✳ **TIP:** As when working with pastel, protect your finished charcoal and watercolour illustration with a sheet of paper when storing it, instead of fixing with normal pastel or charcoal fixative. Normal fixative will ruin the watercolour.

WATERCOLOUR & EMBROIDERY

Embroidery is an unusual and creative way to add extra detail and texture to your watercolour illustrations.

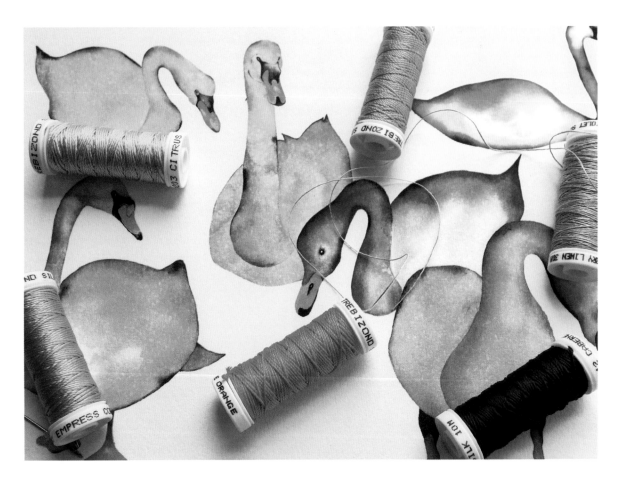

I've found this technique works really well with clothes, flowers, vegetables and animals, but you can try it with any subject matter you feel like. You can get embroidery thread in all kinds of colours, and even metallic and fluorescent threads exist, so if this is a look you find interesting, you can experiment with colours and different kinds of stitching too.

WATERCOLOUR & EMBROIDERY: SWANS

{1} Draw the outlines of the swans in pencil. {2-3} Paint the swans – you can use any type of watercolour for this. Use light pastel shades, choosing one pastel colour for each swan, and creating light and dark variations in colour by adding more or less water to the paint. Use grey for shadows and details, and paint their faces, beaks and feet in black, yellow and orange. {4-5} Let the watercolour dry, then start with the embroidery. You'll want to use strong and bright colours to stand out against the pastel tones, and you might even want to try fluorescent or metallic threads. Use embroidery on just some parts of the swans. I've used embroidery in two ways here: to define outlines and to create stitched patches (being very careful where I pierce the holes with the needle, to be as neat as possible). Of course, with your creations you can add stitching in any way you want.

{1}

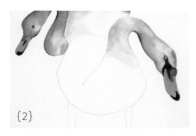

{2}

{4}

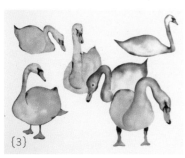

{3}

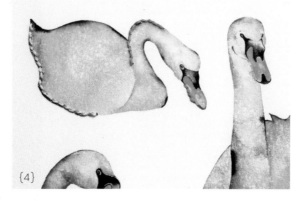

* **TIP: When creating artworks using embroidery you'll need to use thick watercolour paper and a very sharp, thick needle.**

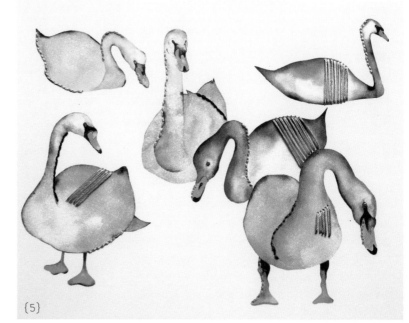

{5}

TEXTURES

Watercolour is excellent for creating textures. The way you can blend colours to produce these textured effects is one of the aspects of using watercolours that I find the most interesting, and the way the colours can blend into each other is a feature unique to the medium.

These textures can be used as backgrounds, materials for collaging and other techniques, or you can simply keep them as they are, as artworks in their own right.

You can use as many colours, or shades of colours, as you want, to make beautiful patterns – the sky's the limit, so be as subtle or bold as you like!

CREATING TEXTURES

Here's how to create the textures that you can then go on and use in different ways – I'll show you some of my favourites over the following pages. It's easy to be creative with textures, and impossible to go wrong, so have fun playing!

{1} Start by fixing a piece of paper to the table, using adhesive tape to create a border that seals the paper along all four edges. The tape needs to overlap the edge of the paper and stick to the table with no gaps, to ensure the paper doesn't buckle unevenly when you add the water. {2} Moisten the paper with a sponge. Let it dry for a few minutes, or use a hairdryer if you don't want to wait. {3} Drip some watercolour paint on to the paper. I prefer to work with liquid watercolours for this because you can pour them directly from the bottle, whereas solid or tube watercolours need to be mixed with water first. {4} Once the colour is on the paper, you can mix it with a brush or a sponge. Try using the hairdryer to direct the paint as it bleeds. You can experiment with the settings of the hairdryer and its distance from the paper to see what different effects you can get. {5} You can also try using more than one colour – both complementary and contrasting colours make for interesting results.

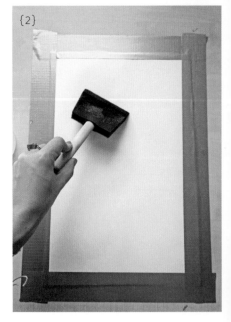

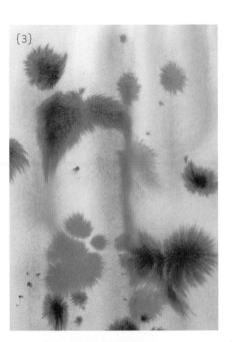

{3}

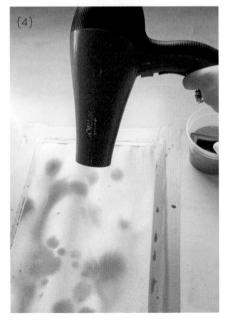

{4}

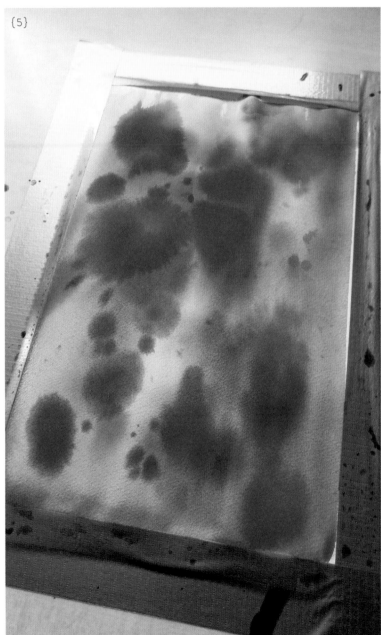

{5}

COLLAGE

A collage is a brilliant way of creating an eye-catching illustration using shapes cut out from the textures you've created.

You won't want to choose anything too intricate for your collage. Broader shapes will allow you to show off the patterns of the textures, whereas you wouldn't really be able to see them with smaller cut-out elements. As you can see, the birds and leaves in this illustration work well because the cut-out shapes aren't too fussy.

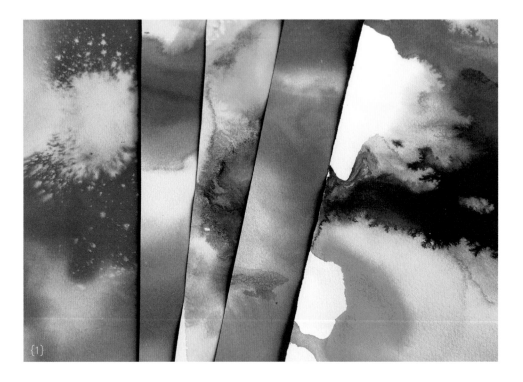

{1}

COLLAGE: BIRDS COMPOSITION

{1} Collect together the watercolour textures you want to work with. They need to be dry before you begin. {2} Draw out your illustration on paper. The illustration should be made up of simple shapes broken up into smaller segments. {3–4} Cut out the main shapes of the illustration, leaving the segments within shapes uncut for now. Use these cut-out shapes as templates to cut out the same shapes using the watercolour textures. Arrange the texture shapes on the page. {5} Keep cutting away the templates into their smaller segments to use as smaller templates to cut out the watercolour textures. Layer the smaller cut-out shapes from the watercolour textures on top of the larger ones, to build up detail.

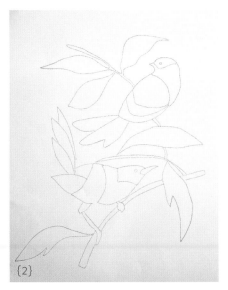

{2}

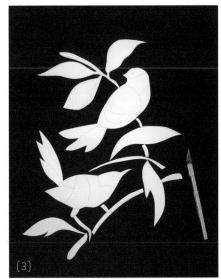

{3}

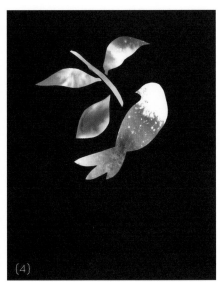

{4}

One of the nice things about collage is that you can move things around on the page until you are happy with the way they look. Cut out holes for the birds' eyes using a scalpel or cutter, or draw the eyes in with black pen. Glue the collage into place with adhesive.

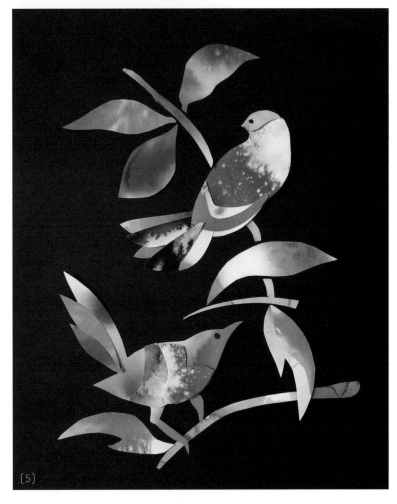

{5}

SILHOUETTE

A silhouette cut-out is another great way of using watercolour textures, and this is a technique that can work well with both simple and intricate cut-out designs.

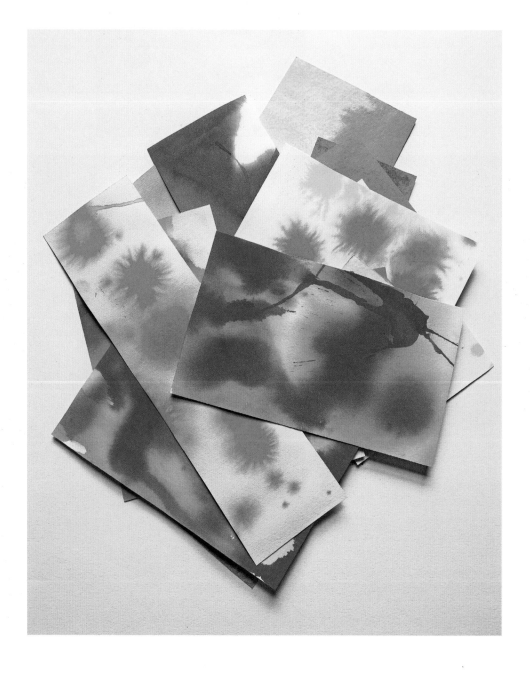

{1}

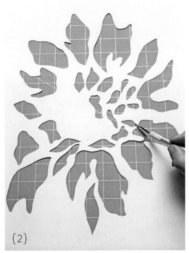

{2}

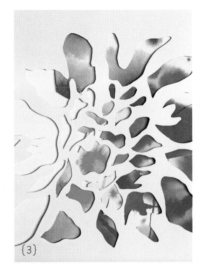

{3}

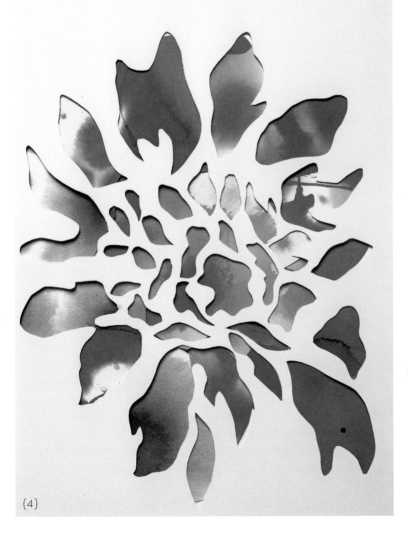

{4}

SILHOUETTE: PAPER-CUT FLOWER

{1} Draw the design of the flower in pencil. {2} Use a scalpel or cutter to cut out the design. {3} Turn over the paper so you don't see the pencil marks. Cut out some textured papers to lay under the silhouette, so that they show through the cut-out areas. Here, I have cut and moved the different textures so that red shows through in the centre of the flower, and blue around the outside. {4} Fix the textures into place using adhesive.

✳ TIP: Be careful if your design has 'islands' (loose pieces that are needed to form the silhouette design) when you cut it out, as you will have to keep the pieces to glue on to the illustration later. This isn't a problem, it can make for an interesting 'silhouette within silhouette' effect, like on page 118, you just need to think ahead!

JIGSAW PUZZLE

This technique makes me think of the paper dolls you can dress with cut-out clothes. It's sort of a cross between a collage and a puzzle.

This kind of illustration can work for anything, not just fashion subjects, but it's more effective with simple designs rather than complicated ones.

{1}

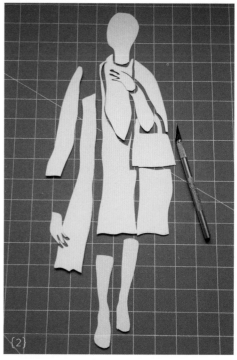

{2}

JIGSAW PUZZLE:
FIGURE

{1} Draw the outlines of the figure in pencil, marking out the separate parts of the design: the head, clothes, legs, etc. All of the parts will fit together like a jigsaw puzzle once they're cut out. {2} Use a scalpel or cutter to cut out the different pieces. {3} Use the cut-out pieces as templates to cut out the same shapes from the watercolour textures. It's fine if the cut-outs aren't exactly precise – consider the templates as guides. In fact, it's part of the effect if the parts don't fit together exactly; as you can see from the finished illustration, it looks good with a sliver of white between some of the elements. {4} Arrange the cut-out pieces on the page. {5} Fix the elements into place using adhesive.

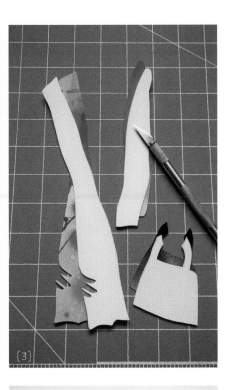

{3}

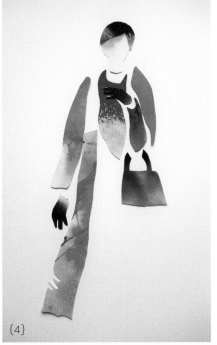

{4}

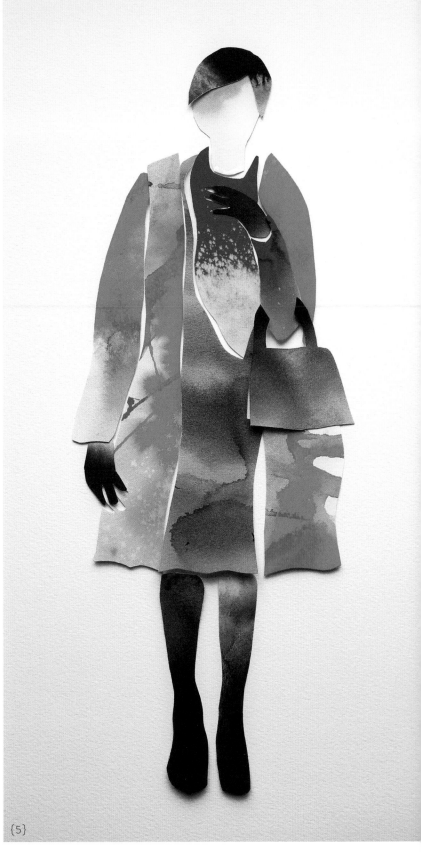

{5}

USING WATERCOLOUR WITH OTHER MATERIALS & OBJECTS

You can use all kinds of surprising, everyday things that you have in the home for your artworks. It might not have occurred to you that things you already have in the kitchen or bathroom could be materials or tools for working with watercolours!

Once you start experimenting though, you will find that there are many things you can use that can produce great results and amazing effects that you never knew were possible.

HAIRBRUSH/COMB

Brushes and combs make excellent tools for creating rough, sketchy textures. I often use them for fashion and nature illustrations and this is one of my favourite techniques.

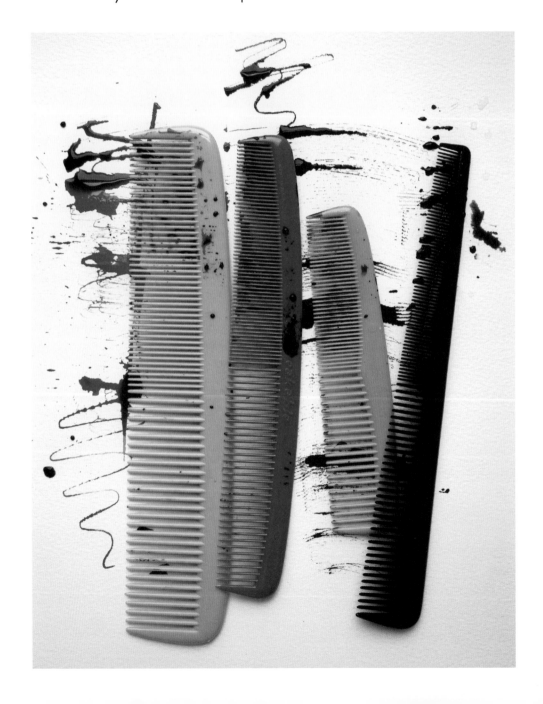

HAIRBRUSH/COMB:
CATWALK ILLUSTRATION

The comb technique adds a sense of movement to the illustration and makes it very striking. It also works perfectly to give the skirt volume.

{1} **Paint the illustration in watercolour, leaving a blank space for the skirt.** {2} **Let it dry. Put your red undiluted liquid watercolour in a bowl and dip the comb in. Don't put too much paint on the comb or it will drip. A few drips look great, but you don't want them everywhere.** {3} **Use the comb to create the scratchy outline of the skirt in red, in the blank space you left for it. Then do the same using black liquid watercolour over half of the skirt while the red paint is still wet, to get a contrasting two-tone effect.**

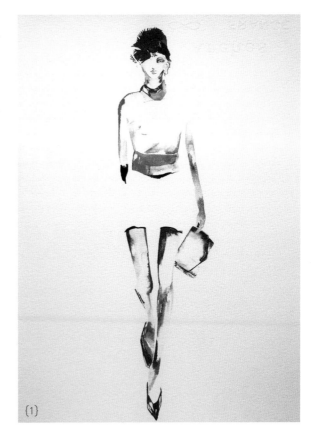

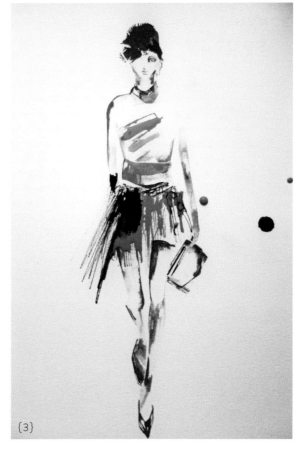

{1}

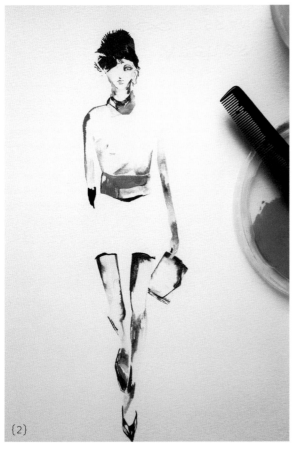

{2}

{3}

TOOTHBRUSH

Toothbrushes also work really well with liquid watercolours. Their bristles are stiffer than those of normal watercolour brushes and this creates a different kind of line.

TOOTHBRUSH: ROOSTER

This is an example of a really dynamic effect created by a toothbrush as a finishing touch to an illustration.

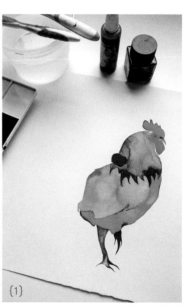

{1}

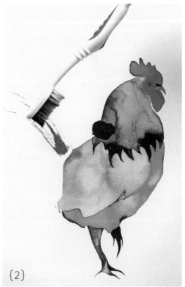

{2}

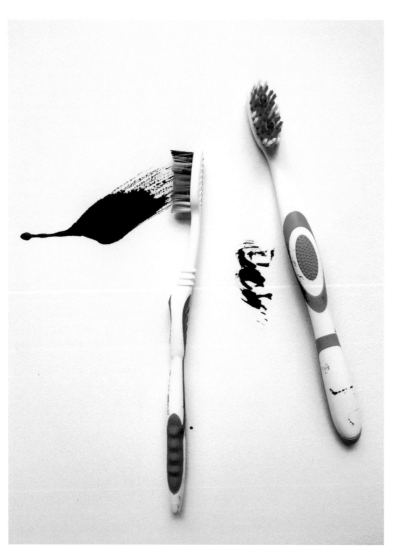

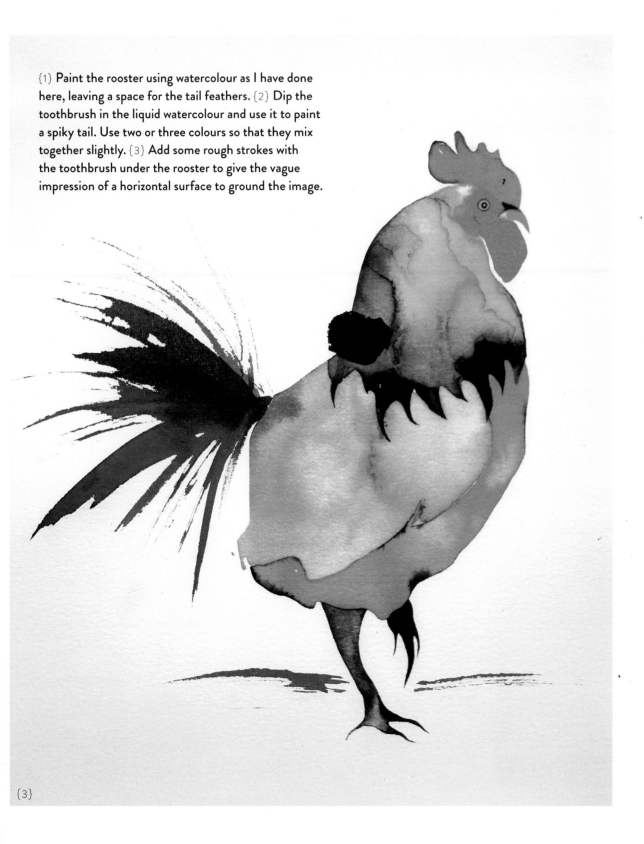

{1} Paint the rooster using watercolour as I have done here, leaving a space for the tail feathers. {2} Dip the toothbrush in the liquid watercolour and use it to paint a spiky tail. Use two or three colours so that they mix together slightly. {3} Add some rough strokes with the toothbrush under the rooster to give the vague impression of a horizontal surface to ground the image.

{3}

SALT

Salt absorbs the colour of watercolour paint, and can be used to create an amazing and unusual mottled effect. Who could have imagined that such a dramatic effect could be created using nothing more than ordinary salt?

You can use textures made using salt in many other projects – collage, silhouette and so on – or you may find they look so interesting that you want to leave them just as they are.

{1} Prepare the paper by taping it to the table using adhesive tape along all four edges, leaving no gaps. Apply water to the paper using a sponge. {2} Add liquid watercolour to the page however you like. It's fine if it bleeds – that's part of the effect. {3} Blend some of the colours together with a brush or use a hairdryer to blow the paint into different shapes. Make sure the paper remains quite wet. {4} Pour salt over the paint in an uneven way to create areas of contrasting textures. Let it dry completely, then brush off the salt.

SALT: TEXTURE

* TIP: I find using sea salt and finer-grain table salt creates further variation within the texture – you can experiment with mixing the different kinds.

{1}

{2}

{3}

{4}

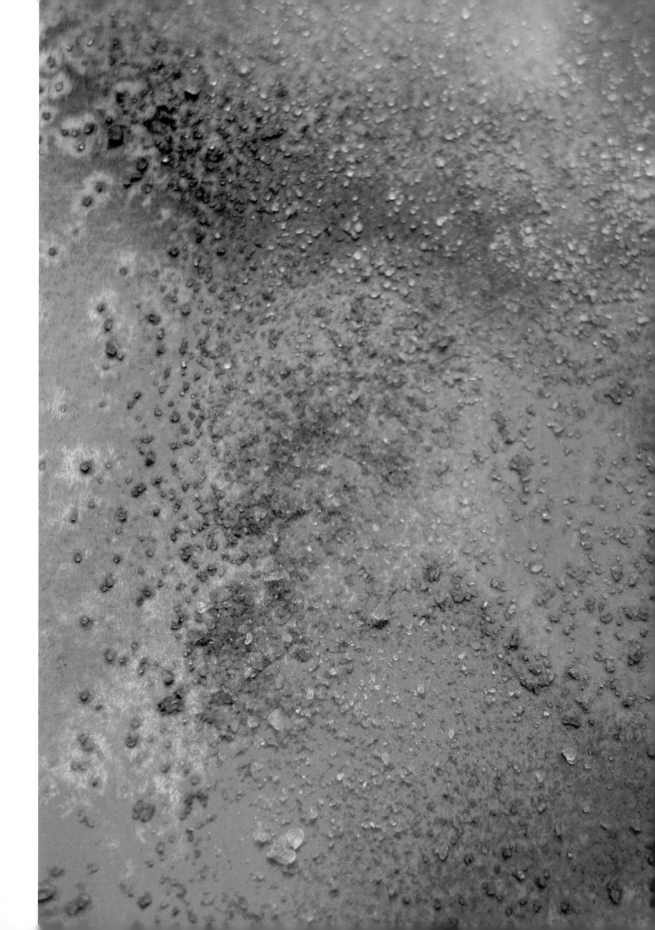

BLEACH

Ordinary household bleach is another surprising material that we can use in our watercolour artworks. It's great for experimenting with textures.

Bleach repels colour, leaving a slight yellow tone or white area where it has been applied. The effect can be quite similar to the effect you get when using a liquid mask (see page 72), although using bleach is less precise.

 I like to use the bleach technique when I'm creating illustrations of textile patterns, flowers and plants, and for making abstract patterns (it can produce a brilliant 'tie-dye'-style effect as you can see from the image below on the right). It isn't something you'd choose for realistic or detailed works though; you can work much more precisely using a liquid mask.

 Using bleach can be a little tricky at first – it takes a bit of practice. Use a small amount of bleach and a spray bottle to apply the bleach to the paper. When using brushes, make sure you don't use your favourites – use old or inexpensive ones because the bleach will ruin them! You'll also need to use thick paper otherwise you'll find the bleach eats away at it. And, of course, bleach is strong – make sure the room you're working in is well ventilated, keep your clothes and everything else away from it, and keep it out of reach of children. There are chlorine-free bleaches available, but, personally, I prefer regular bleach – you can experiment with both kinds if you like.

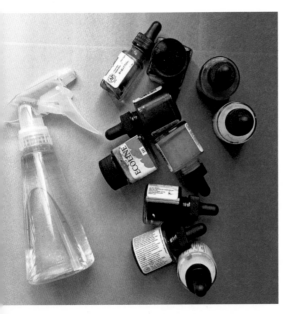

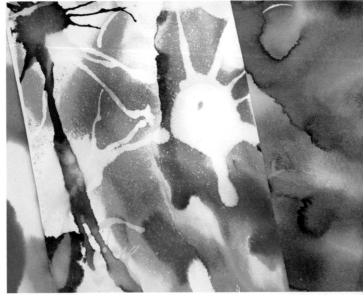

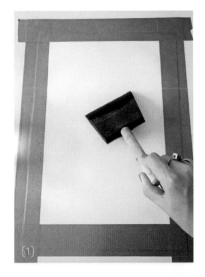

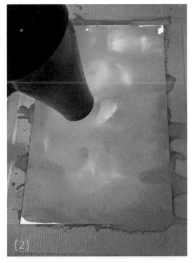

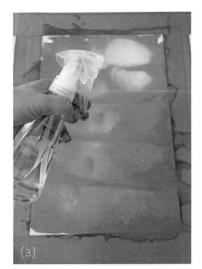

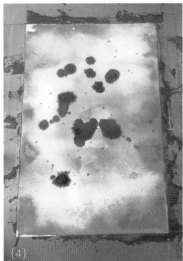

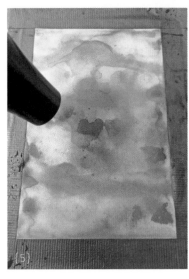

BLEACH: TEXTURE

✳ **TIP: You can experiment with brushes instead of a spray bottle to apply the bleach here. Another alternative is to apply the bleach to the paper first before adding the colour.**

{1} Fix your paper to the table using adhesive tape along all four edges. Moisten the paper with a sponge, and let it dry for a few moments. {2} Pour different shades or colours of liquid watercolour onto the paper and let them run together. Blend them until paint covers the whole page. You can use a big paintbrush to do this or a hairdryer to blow the paint in different directions. {3} Spray some bleach on to the paper using a spray bottle to slowly bleach out the colour. {4} Let the paint and bleach dry completely to see how the texture has changed. You can then keep adding paint and repeating the process with bleach to build up a layered pattern. {5} I also like to use a hairdryer to blow the paint and bleach across the page, but point the hairdryer away from you so you're not blowing bleach at yourself. Add colour and bleach as many times as you want until you're happy with the result.

LIQUID MASK

Liquid mask, or masking fluid, is another medium that you can use to repel paint. You apply it to the areas on the page that you don't want coloured, and then paint over it; once it's dry, you can rub away the liquid mask to leave only the painted areas that weren't masked off.

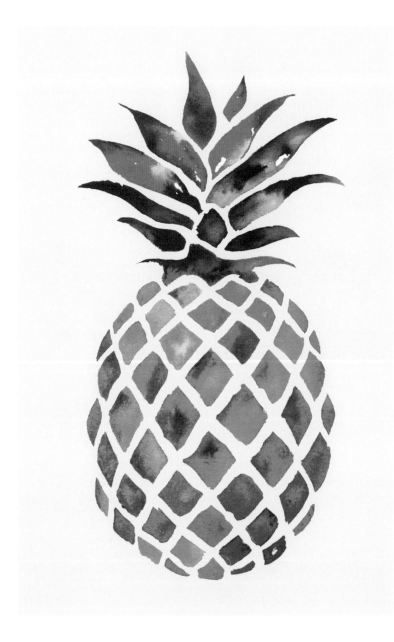

This has a similar effect to that of a stencil, in that it only allows colour on to some parts of your design. You can use the technique for detailed work as the liquid mask makes a neat and effective barrier.

✳ **TIP:** You can dilute liquid mask slightly with water to make it easier to apply, but don't dilute it too much, or you won't be able to remove it from the paper. Never dry paint applied over liquid mask with a hairdryer as the heat will melt it!

LIQUID MASK: PINEAPPLE

{1} Draw the design of the pineapple with a pencil. {2} Use the liquid mask to paint over the areas that you want to remain white. Use a cheap or an old brush. Let it dry. {3-4} Complete your design using watercolours, filling all the areas that you want to be coloured. Blend shades of green for the pineapple top, and shades of orange and brown for the main fruit part. When the paint is dry, remove the mask with the help of a scalpel, cutter or eraser.

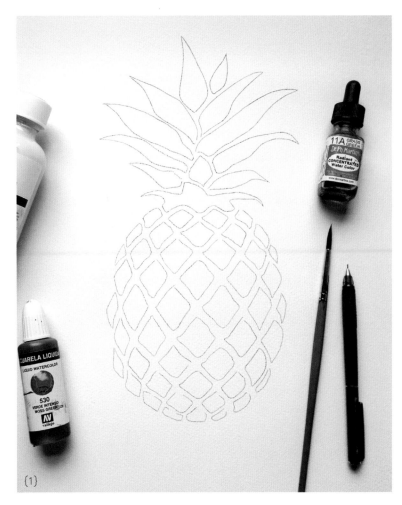

{1}

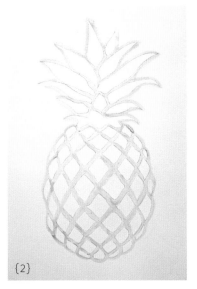

{2}

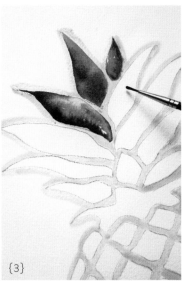

{3}

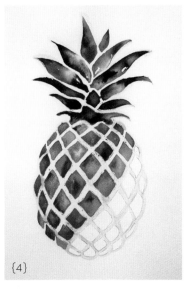

{4}

TUTORIALS

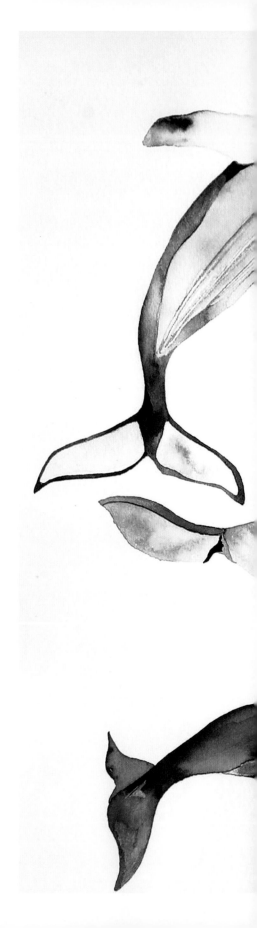

In this section there is a series of different tutorials that you can follow to create graphic and showstopping watercolour pieces. There are projects that focus on food, still-life, fashion, animals and nature, and cityscape subjects to enable you to have a wide range of techniques and styles in your artistic repertoire.

You might find that you prefer some styles to others or that some techniques are more effective for you. Feel free to experiment and go off-piste to make the projects your own, and don't forget that you can adapt them to suit your own needs and interests and what you want to paint or create.

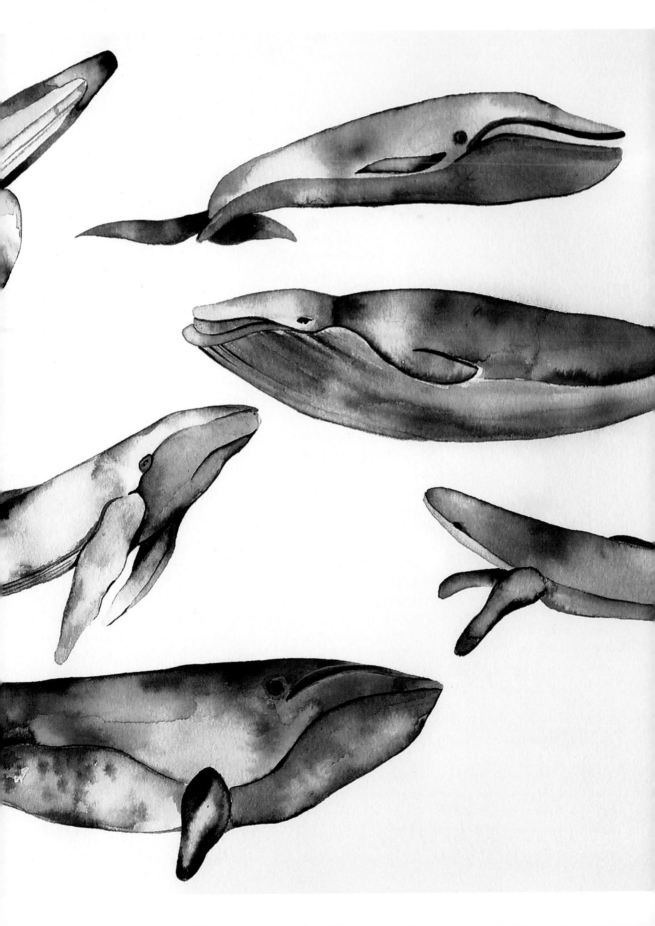

FOOD

WATERCOLOUR WITH TECHNICAL PEN & CHINESE INK: ARTICHOKES

Using watercolour with technical pen works really well as the ink is waterproof. This technique is not entirely unlike the mixed media example on page 40 where I created an illustration of a radish using Chinese ink and watercolour, only this time I also used technical pen to create a more detailed illustration. The very fine lines drawn in pen depict the lined texture of the artichokes, and the bold outlines done in Chinese ink contrast nicely with the 'messy' style of the watercolour.

{1} **Draw the outlines of the artichokes.** {2} **Go over your pencil lines in black technical pen. Start with a medium-size nib like 0.25mm and vary the line width with thicker nibs such as 0.35mm and 0.45mm to make the drawing feel more natural.** {3} **Using a very thin nib like 0.2mm, add finer lines to show the texture of the artichokes.** {4} **Using a thin brush, thicken the main lines of the artichokes with Chinese ink to make them bolder and less regular – this adds a bit of contrast and makes the artichokes look more three-dimensional.** {5} **Let the ink dry; meanwhile you can prepare your colours. You'll want several different shades of violet, green and brown. Before starting to paint, apply a little water with a paintbrush to the artichokes. Have the water go over the edges in some areas, as this will allow the colour to overrun the lines and give an imprecise, soft effect.** {6} **Add the violet paint to the image, followed by the green and brown colours. Let the colours blend a little into one another, and allow the paint to run outside the lines.** {7} **Apply more water to areas where you want the paint to bleed further for a more textured effect. You can also use a cotton bud to soak up colour to add highlights.**

{5}

* **TIP: Cotton buds are perfect for absorbing colour to produce a highlighting effect. Because they are so small you can easily, and very precisely, control how much colour you want to remove.**

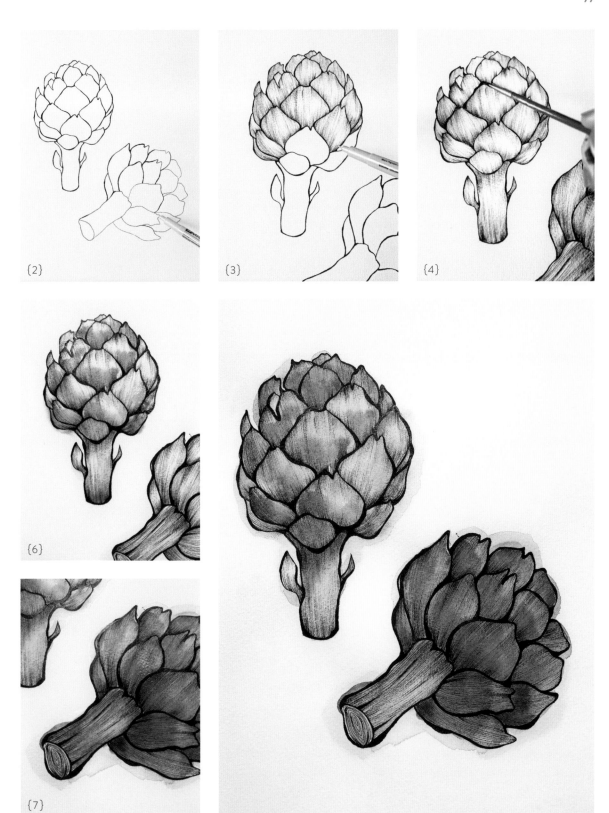

{2}

{3}

{4}

{6}

{7}

COLOUR SCALE: VEGETABLES

The idea of this illustration is to depict a colour scale of vegetables, beginning with green and moving through red to indigo. Each element is separate, but the transition of colours brings the illustration together as a whole.

{1–2} **Draw the outlines of the vegetables in pencil. Paint the vegetables with your watercolours; I suggest a mix of solid and liquid paints and a medium-sized brush. Start with the lighter colours to fill in the base colours, then apply darker shades for the shadows and textures.** {3} **Use a finer brush to add details.**

{1}

{2}

{3}

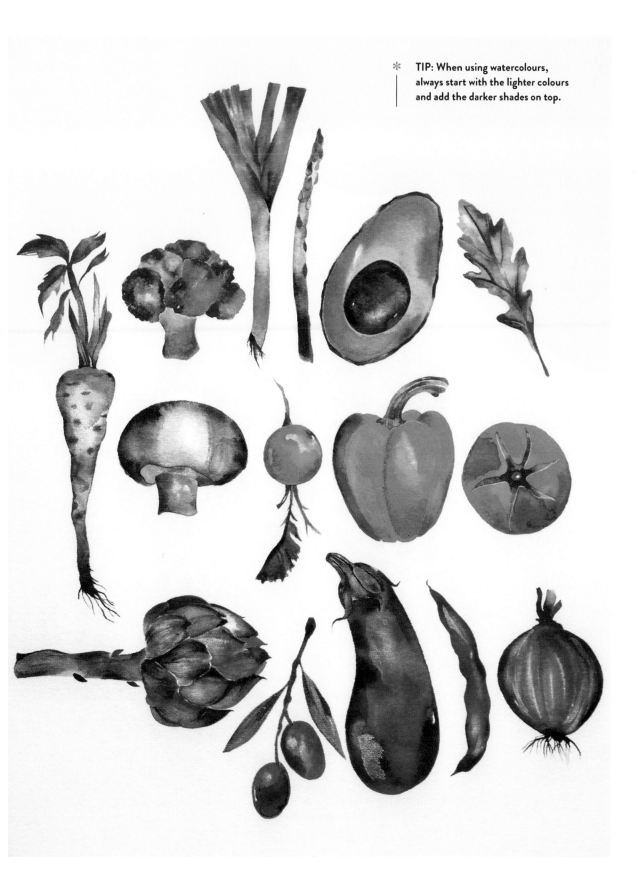

* TIP: When using watercolours, always start with the lighter colours and add the darker shades on top.

DOT EFFECT: PEPPER & CHILLI

Using dots of different colours is
a striking and unconventional way
of creating an illustration. For this
technique I recommend you use
a more solid consistency of paint
rather than a very watery mix.

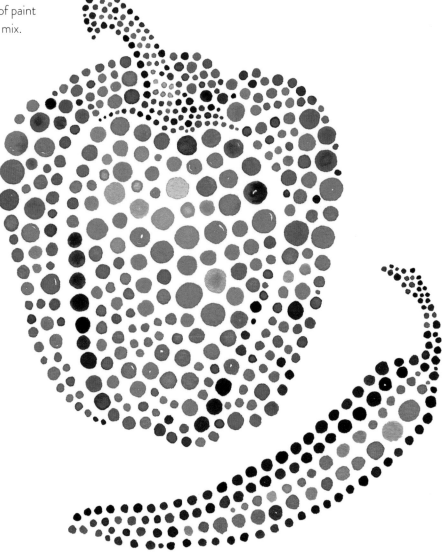

{1} Using a pencil, draw out the shapes of the chilli and the pepper using dots of varying sizes. You can see that I have used smaller dots for the stalks to differentiate those areas. {2–3} Fill in the dots using a brush and different colours to create dots in a range of shades. You can use darker tones for shadows and lighter tones for brighter areas. On the pepper, I've used yellow dots to show the brighter areas where the light falls, and on the chilli, I've used a much lighter green. Wait until the paint dries completely, then erase the pencil marks.

* TIP: Leave gaps where you would draw a dividing line between the different parts of the vegetables. On the main body of the pepper, for example, the way I've grouped the dots together and left gaps between them helps demarcate the different areas of the vegetable.

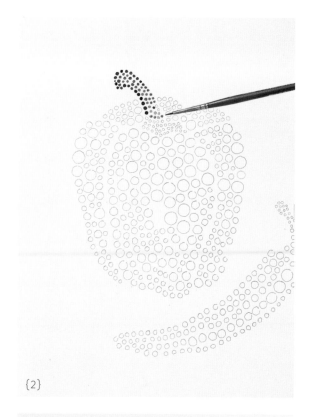

{2}

{1}

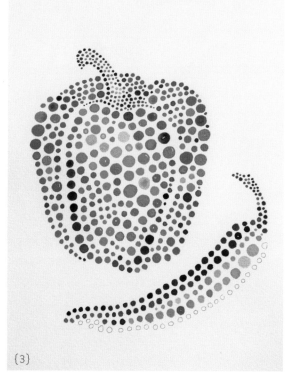

{3}

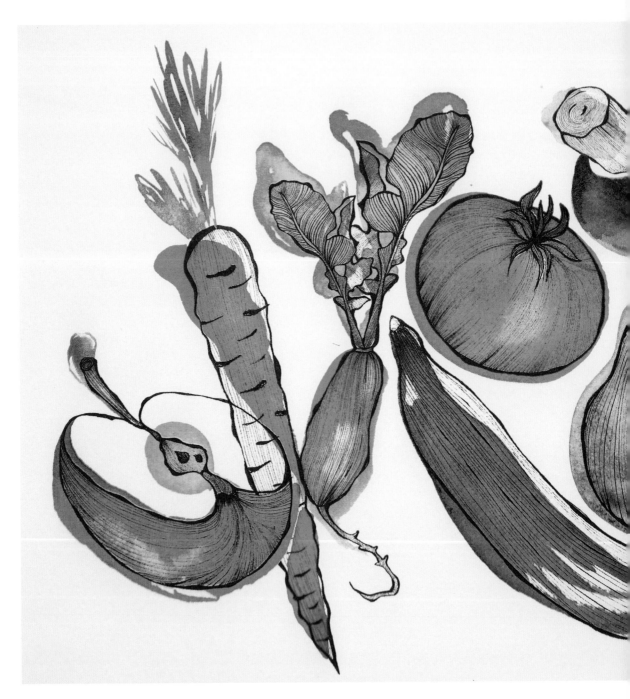

* **TIP:** Being deliberately imprecise
 with your application of paint –
 going over lines, or not filling in
 areas completely – creates a lively,
 carefree feeling in an illustration.

WATERCOLOUR WITH TECHNICAL PEN: VEGETABLES & FRUITS

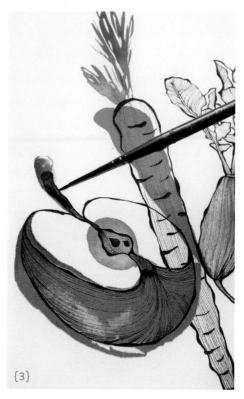

{1}

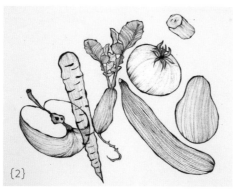

{2}

{3}

Another example of using technical pen with watercolour; this is a dynamic illustration that isn't constrained by outlines, and it's a style I love. I recommend you use liquid watercolours with this technique because they give a more fluid effect.

{1–2} **Draw the vegetables in pencil. Go over the lines in technical pen, using different sizes of nib to vary the line widths, with thicker main outlines and thinner lines to show the textures. You can leave out some of the parts of the vegetables without technical pen, to be painted in with watercolour only. Here I've left the carrot top and the mushroom cap, which work really well simply in watercolour; the mushroom cap looks spongy, and carrot top soft and leafy. {3} Apply your watercolours over the technical pen lines. Don't fill in the outlines perfectly – only fill in part of the vegetable or fruit with some of them, as I have done with the apple and the cucumber, and go over the lines with others, as I did with the tomato, pear and radish. Fill in any parts you left blank, like the mushroom cap and the carrot top.**

WATERCOLOUR & COLOURED INKS: FISH COMPOSITION

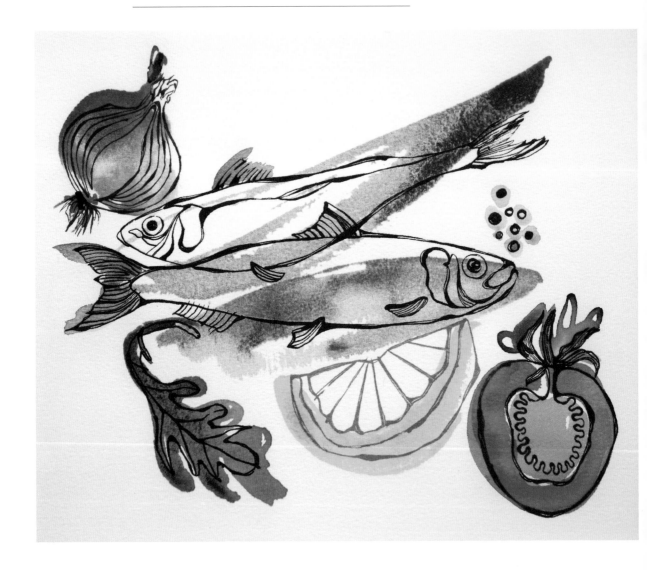

This method is another way of creating an interesting and unconstrained illustration; here I'm using different coloured waterproof inks with watercolour applied on top of them to create a more decorative effect. In addition, I've used a dry sponge to absorb some of the paint in places, and this produces a subtly contrasting mottled effect.

✳ **TIP: Coloured inks are great for elegant linework and, because they're waterproof, you can just apply strokes of watercolour right over them.**

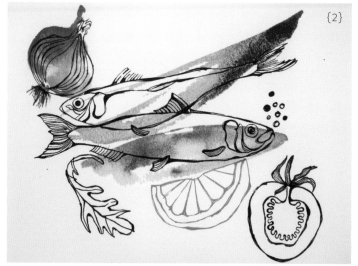

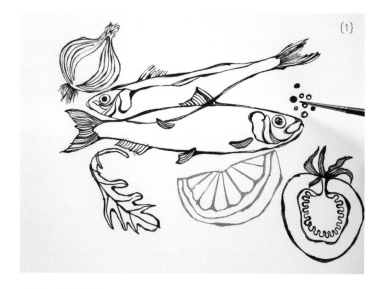

{1} Draw the outlines in pencil and use a thin brush to go over them with waterproof ink. Use different colours – I have used purple for the onion and orange for the lemon, in contrast with the black I used for the other elements. {2} Wait for the ink to dry and prepare your colours. Choose one colour for each of the different elements. Apply the paint in a loose way that gives just a rough idea of each of the individual shapes. {3} For the fish, apply the main colour with a streak of darker colour. Use a dry sponge to absorb some of the paint to create the mottled texture.

STILL LIFE

The idea for this illustration is that the objects are of just one colour; I've only used shades of red, with some black and white to add details. Working with just one colour is a great way of showing you how I use layering, which is a specific technique you can use when working with watercolour, and gives a very sophisticated look.

{1} Draw the shapes of the objects in pencil. Apply the paint to each of the elements using a medium-sized brush. Start with a light shade of red as the base layer, and work in layers, adding colour to build up the intensity of the colour. For some of the objects you will want to build up to as many as four or five layers. {2} Use a thin brush to add in the details. First, work on the shadows, using a darker tone of red, grey or black. Before applying the darker paint, add a little water with your brush, then apply some drops of the darker colour; blend it with your brush so that it mixes with the lighter red. {3} Now add the highlights. You can do this by adding some drops of water, which will lighten the red colour, or waiting until the paint is dry and adding in reflections or other details with white watercolour paint – you can see that I've used both of these techniques in this illustration.

{1}

{2}

{3}

* TIP: Moving from the top of the paper downwards as much as possible is the easiest way to work – you won't find yourself smudging what you've already painted.

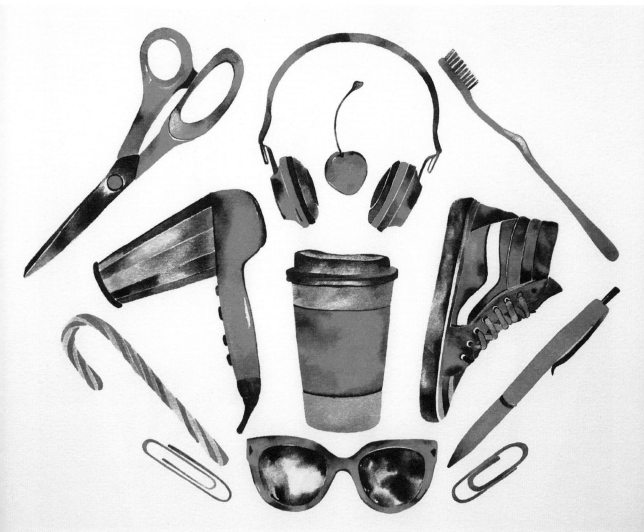

JIGSAW PUZZLE: CHAIR

This jigsaw-puzzle-style technique with watercolour textures can be applied to any simple objects as subject matter, and I find that if you use black as a backing to contrast with the watercolour textures, it really makes the colours pop.

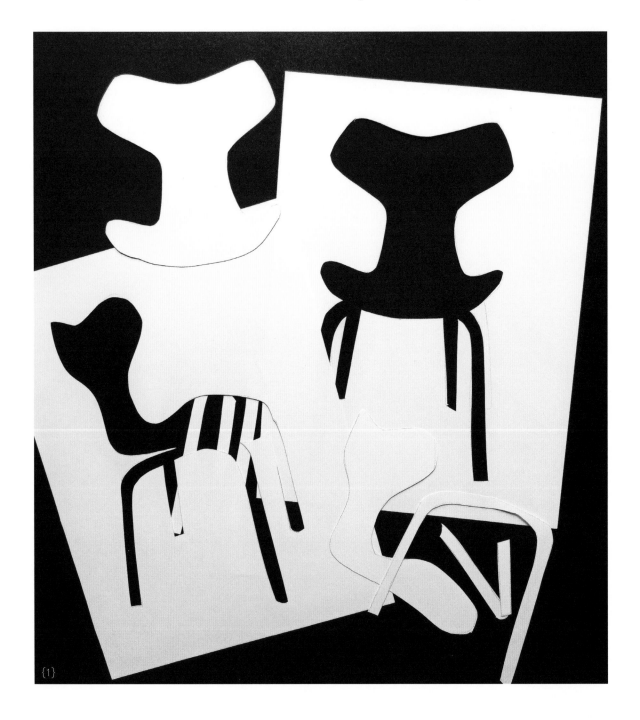

{1}

{2}

{1} Get your watercolour textures ready; they need to be dry before you begin. Take some thick paper and draw the outline of the chair. Cut out the outline shape with a scalpel or cutter, and save both the silhouette and cut-out piece. {2} Separate out the different parts of the chair cut-out shape with scissors or a scalpel. Use the cut-out pieces as guides to cut out the shapes of the chair from the watercolour textures, choosing different colours for each part of the chair. {3} Glue the pieces into place on a white, black or other contrasting coloured background.

✳ TIP: You can save the silhouette and fill it with watercolour textures like in the method used for 'Silhouette: flower vase' (see page 94).

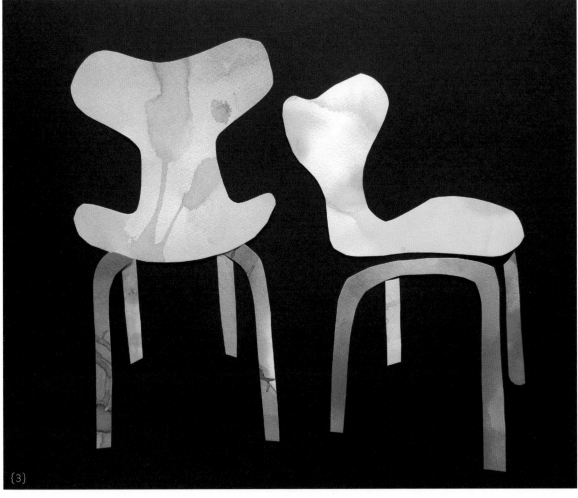

{3}

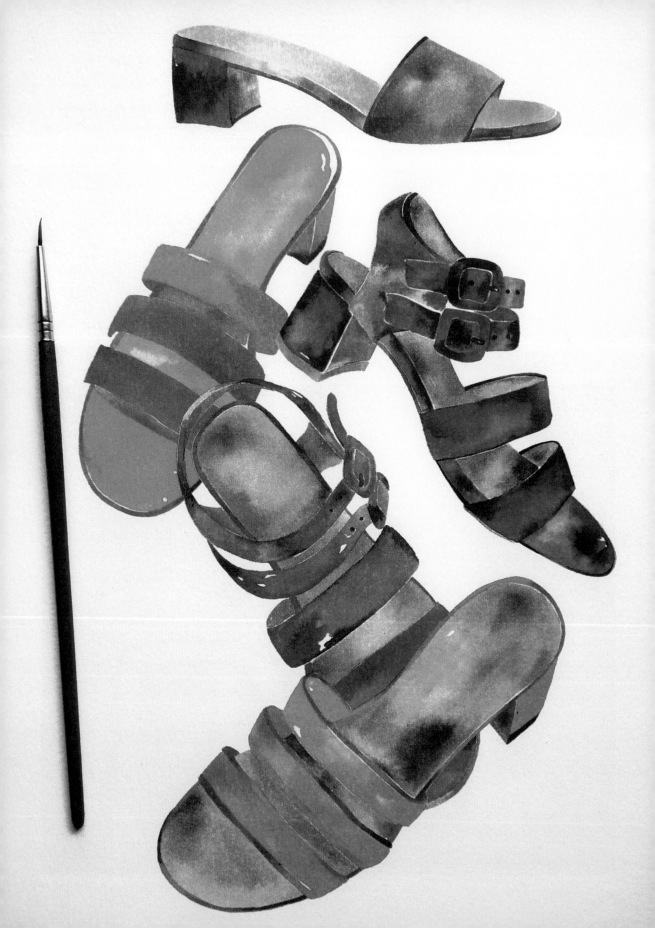

REALISTIC STYLE: SHOES

This illustration of shoes in a realistic style is another example showing just what you can do using the layering technique and a limited palette of colours.

{2}

{3}

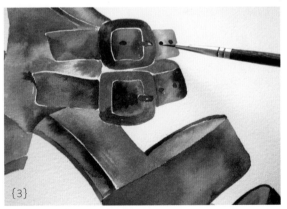

{1}

{1} Draw the outlines of the shoes in pencil. Paint the shoes, working from the top of the page downwards, and moistening each area with water before applying the watercolour. Start with the lighter areas, mixing in more water to create the lighter shades. {2} Use darker tones for the textures and details, and add grey to the paint for shadows. Make sure that each layer of paint is dry before painting the next, as this more realistic style calls for a neater approach and for details not to bleed too much. {3} Add the finishing details in black with a fine brush when everything else is completely dry.

COLOUR CONTRAST: MAKE-UP

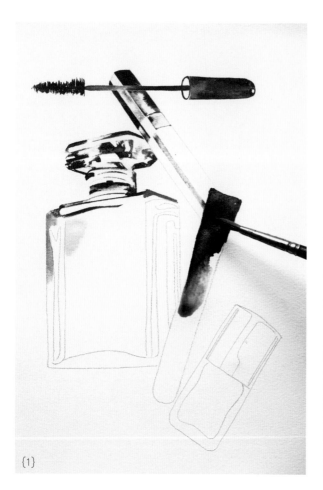

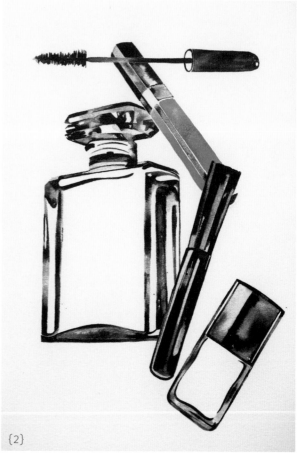

{1}

{2}

Here, I've created a make-up illustration with the base outlines in black and grey, filled in with bright, saturated colours. I think this is a look that suits the subject matter perfectly!

{1} Draw your composition in pencil. Use black and grey tones of watercolour to go over the lines and shade in the darker areas. Moisten areas using a paintbrush loaded with water to allow shades of grey and black to flow easily and use water to lighten areas and add texture. You'll need to leave a space blank for the bristles of the make-up brush, which you'll fill in later. {2-3} Wait until the black and grey are dry, then start adding the colours; be careful

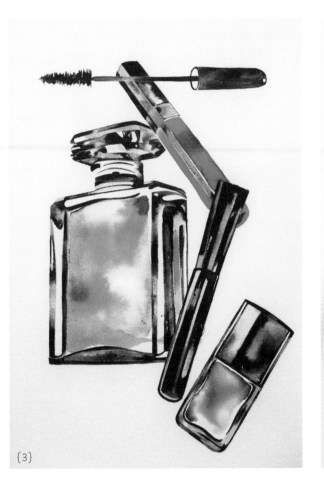

{3}

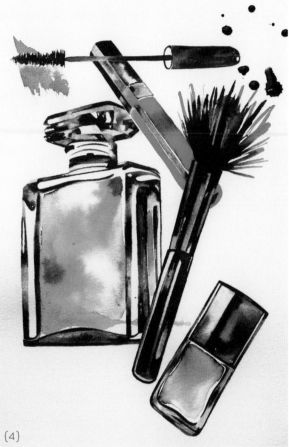

{4}

when you're doing this because the black and grey will smudge if you get too close to them. As before, add water to lighten the colour, and add a few drops of black to create variation within the coloured areas. Use a thin brush to first do the outlines of the shapes to be filled and then a bigger brush for the actual filling in to contain the colour precisely. {4} When the fill colours have been added and are dry, paint in the bristles of the make-up brush. Apply the black paint and then the colour on top of it to get a jagged and deliberately rough effect. Spatter a few drops of black paint on to the paper, giving an extra touch of dynamism to the illustration, and finish off by adding some colour around the tip of the mascara wand.

SILHOUETTE:
FLOWER VASE

This is a playful cut-out illustration using different watercolour textures. You can create textures especially for the project, or use ones you have to hand. Make sure they're dry before you start!

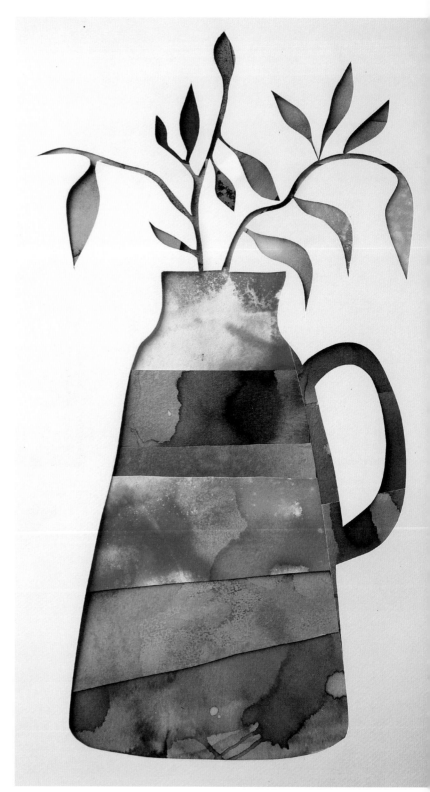

* **TIP: Here, I've cut the textures into strips to work as part of the design – adding stripes to the jug. You can try all sorts of patterns yourself to make your artwork individual to you.**

{1} Have your different watercolour textures prepared, created with paint, bleach or salt. {2} Take a piece of thick paper and draw the outline of the vase and plant with a pencil. {3} Cut out the shape with a scalpel or cutter and remove the inside. Erase any pencil marks still showing. {4} Fill the shape with pieces of texture. I've chosen predominantly green ones for the plant itself, plus some other colours for variety – but it's up to you. Have fun playing around with the arrangement of different papers to get the most interesting-looking result. Fix the textures in place with adhesive.

{2}

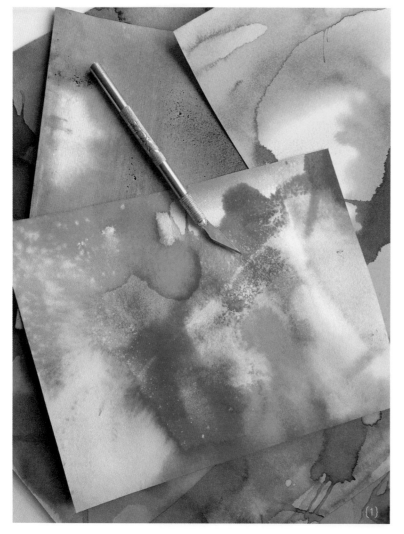

{1}

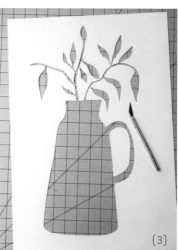

{3}

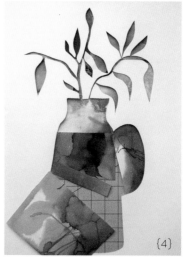

{4}

FASHION

LIGHT & DARK: GREEN JACKET

This illustration draws on the wonderful texturing possibilities of painting with watercolour. I chose a contrasting colour for the boots and hair to make them really stand out from the green.

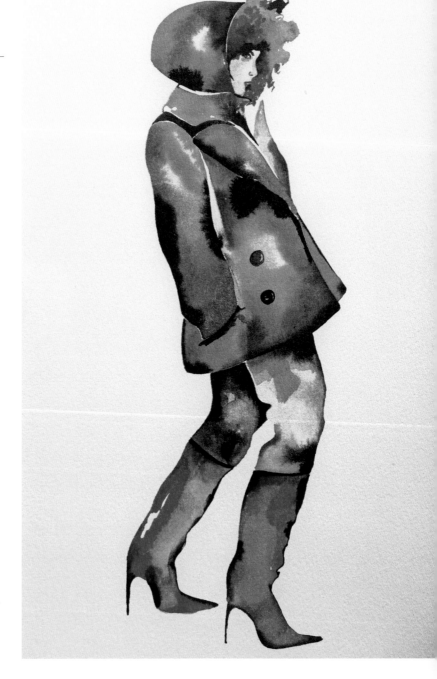

✳ **TIP:** When painting people, first paint in the skin colour – faces, arms and any other areas that show. If you do this later, you risk having the colours of garments bleed onto the skin colour as you add them.

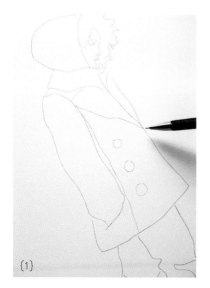
{1}

{2}

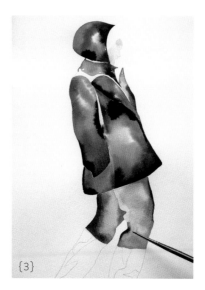
{3}

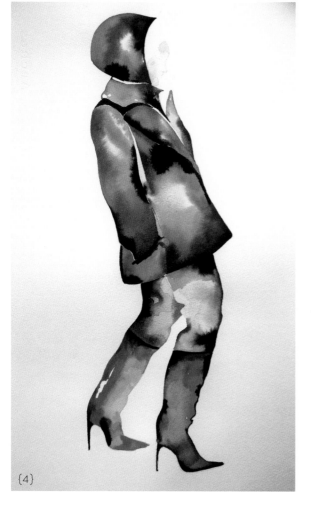
{4}

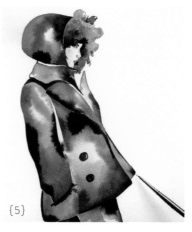
{5}

{1} Draw the outlines of the figure in pencil. {2} Fill the face with a base skin tone. {3-4} Next, move on to the jacket. Before you apply any paint, wet the jacket area with your brush and wait a few minutes. Then start adding just one colour, using a medium brush. Use some grey and black to vary the colour, and create highlights by soaking up colour with a dry brush to make it lighter. Use the same texturing technique for the trousers and boots. Let the paint dry between painting the different areas so that colours don't bleed into one another. {5} Once everything is dry, complete the illustration by painting in the hair, face and any other details, such as the buttons, with a fine brush.

COLOUR BLEED:
RED OUTFIT

Watercolour is brilliant for textiles. Here you can see how the paint creates an impression of flowing fabric, and adds volume to a flat work.

{1} Use pencil to draw the outlines of the figure. Paint the face and hand with a base skin colour, adding grey for shadows. {2} Now for the clothes. Before starting to paint, use your brush to lightly wet the area of the

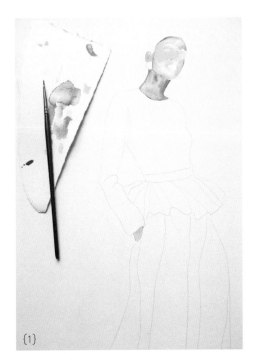

{1}

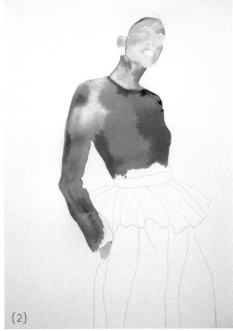

{2}

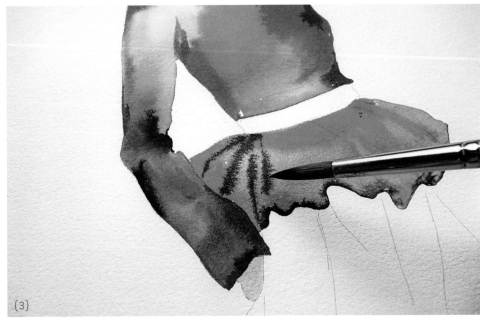

{3}

woman's top. Then paint it red, dropping water onto the colour once you've applied it to create variations in shade. {3} Once you've painted the top in red, take a thin brush and add the shadows and details of the garment in black. I deliberately didn't wait for the paint to dry because I wanted it to run slightly, for a more casual effect. {4} For the trousers I chose a pinker shade of red. Work with big brush strokes from the top of the trousers to the bottom and create highlights by leaving some areas white so that the paper shows through. When you've finished painting in the red, add some black shading to the trousers for texture too. Again, I've added the black while the red is still wet to make the colours bleed. {5} Add the belt, hair, earrings and face with a very thin paintbrush only when all the paint is dry, to make sure they are neat.

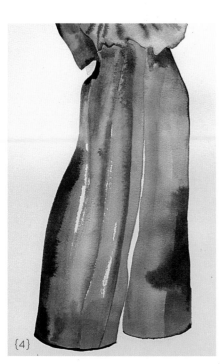

{4}

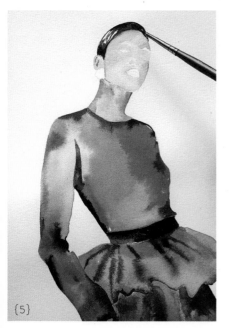

{5}

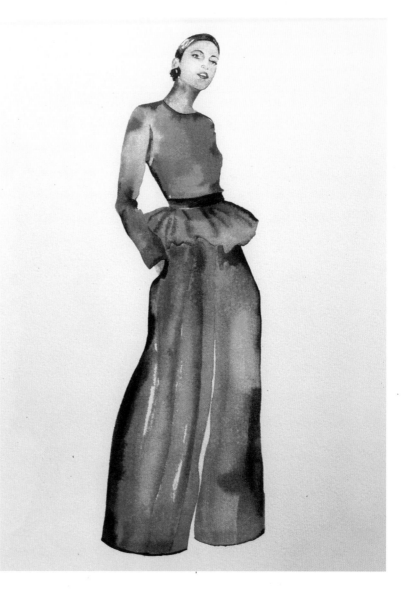

SILHOUETTES: FASHION ILLUSTRATION

I love using silhouettes to create fashion illustrations as you can experiment with patterns and colours quickly and easily, and come up with endless variations.

{1} Draw the silhouette on thick paper and cut out the inside with a scalpel or cutter. Either erase any visible pencil marks or flip the paper over to hide them. {2} Fill the empty space with watercolour textures behind to create a design you like, and glue the textures in place. {3-5} A variant on this technique is to cut out shapes from the watercolour textures to start with and use them to create a pattern. Choose a contrasting colour for the backing of your silhouette (for example, black to go with white or vice versa) and place the watercolour texture cut-out shapes in the window with some of the backing showing through, for a vibrant effect. Play around until you're happy with the design and then glue the pieces into place.

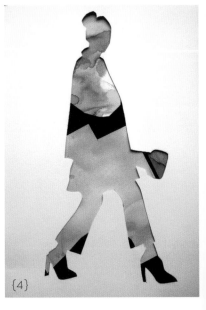

{1}

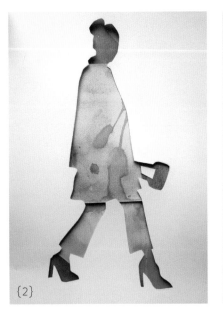

{2}

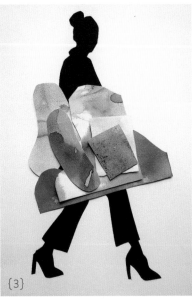

{3}

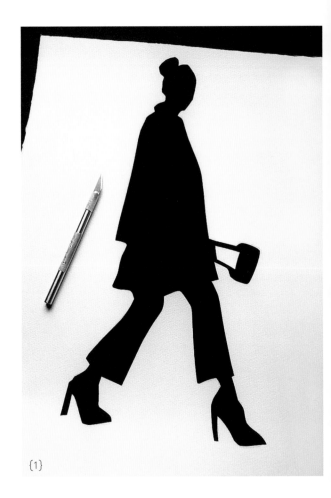

{4}

✳ **TIP:** You can experiment with any
cut-out texture shapes you want to
create regular or irregular patterns –
how about trying polka dots, stripes
or floral designs?

COLOUR SPLASHES: TWO GIRLS

A mix of pencil and watercolour can create a very elegant look. With this illustration, pencil is used to create a detailed drawing, and the splashes of watercolour added to it give a graphic, abstract twist.

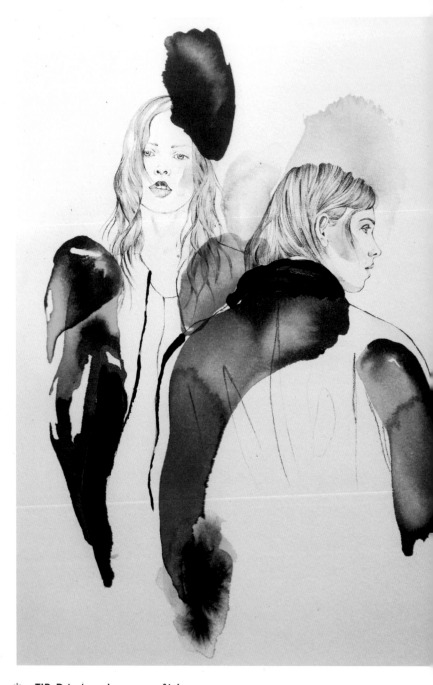

* **TIP: Dripping a drop or two of ink on the page at the end to finish off gives the image a relaxed, artistic look.**

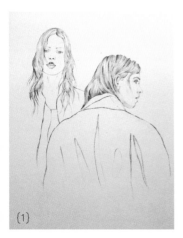

{1}

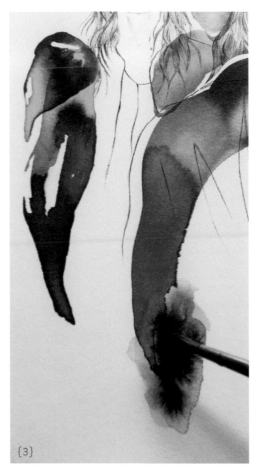

{3}

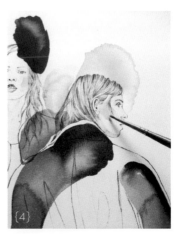

{4}

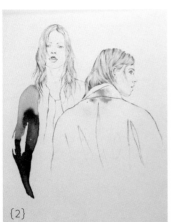

{2}

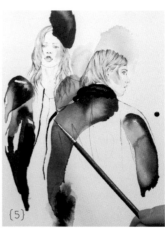

{5}

{1} Create your drawing using pencil. Leave some areas blank to fill in with watercolour later – for example, I chose to leave the sleeve area of the jacket of the girl on the left blank. {2} Now you can start adding the paint. I think liquid watercolour works best with this style as you get a more transparent effect, and I chose to work with a colour palette of just five or six colours to keep it from looking too fussy. The idea is to create a really striking look by combining contrasting colours to produce interesting gradients – such as the blue and dark grey, and green and yellow with black. Use a medium-sized brush and work with big strokes, adding one or two colours so that they can bleed together. Make sure to use lots of water – you can drip more onto the paint before adding another colour so that the colours blend easily into each other. If you're overlaying strokes, you'll need to wait for the paint to dry between strokes, as I did for the girl on the left's jacket sleeve, so that you can see the overlapping layers. {3} Add some light, watered-down coloured patches around the figures to create some atmosphere. {4} Paint in a few very light touches of colour to the girls' faces. {5} Lastly, go over some of the pencil lines in black ink using a small brush.

STENCIL & COLLAGE: FIGURE

Here, I've combined a stencilling technique with some textured collage elements to create a fun fashion illustration. I've kept this one very simple and graphic, but you can add as much detail as you like. The fun with collage is that you can change your mind as often as you want, although sometimes there can be too many choices and you can overthink the design. For this image, I worked very quickly and stopped evolving it when I found something I liked.

{1} **Draw a fashion figure on thick paper. {2-3} Use a scalpel or cutter to cut out the figure. Place the resulting stencil shape over your watercolour paper and tape it to the table to make sure it doesn't move. Use the stencil to fill in the empty space with paint, using different shades for the face and body. I chose pinks and blacks, and used plenty of water to keep the dress colour very light and to create interesting textured effects where the colours bleed into one another. {4} Let it dry and remove the stencil. Now you can start experimenting with your collage pieces to see what colours work and where you might want to place them. With this technique, there is also more of a three-dimensional element to the illustration – if you use tissue or crêpe paper, you can scrunch up the paper or layer it. There's no restriction to what material you might want to collage with – why not try newspaper, foil, cellophane or fabric? {5} When you're happy with the way it looks, fix the pieces into place with adhesive.**

{1}

{2}

{5}

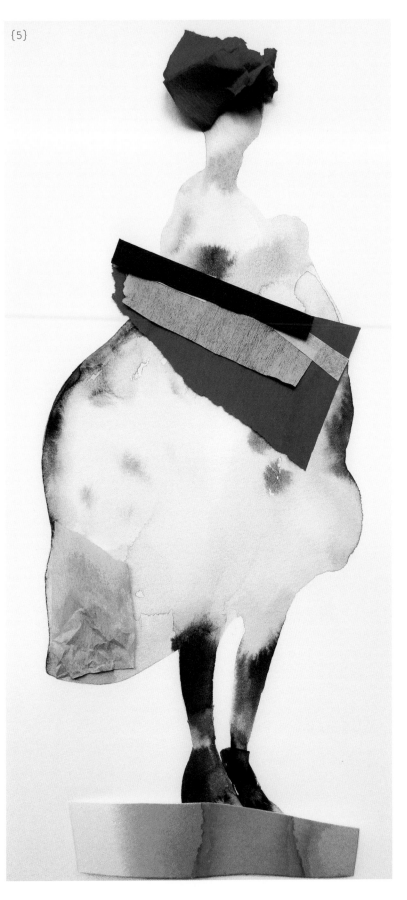

✳ TIP: **TIP:** A variant on this stencil technique would be to paint a background first, let it dry, and use the stencil to paint the inside on top of it. Then, when you remove the stencil, you are left with the shape on a background already.

{3}

{4}

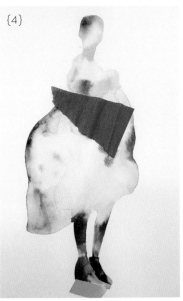

ANIMALS
& NATURE

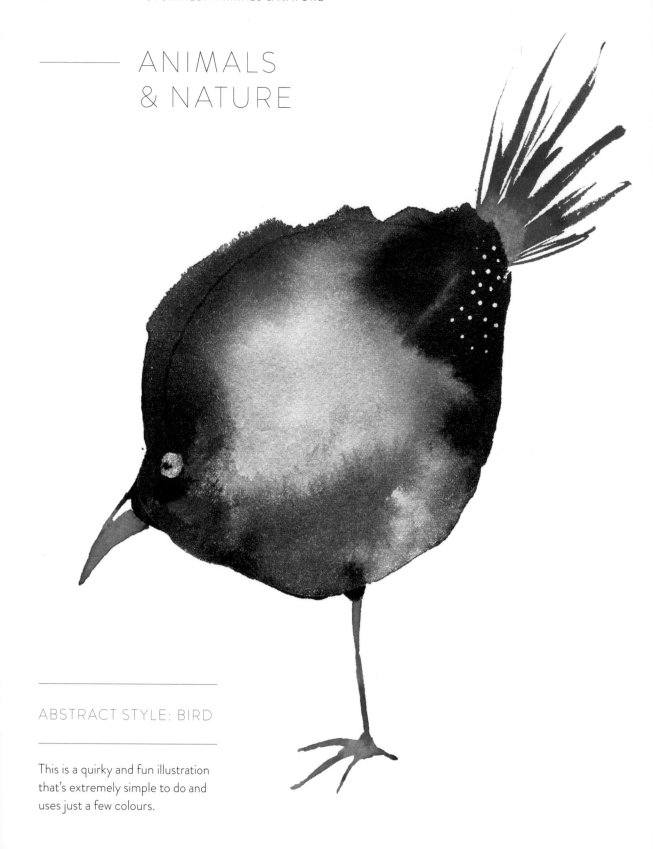

ABSTRACT STYLE: BIRD

This is a quirky and fun illustration
that's extremely simple to do and
uses just a few colours.

{1}

{2}

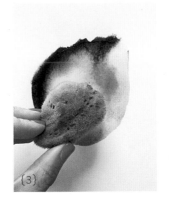

{3}

{4}

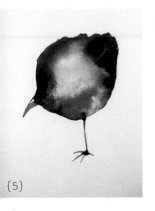

{5}

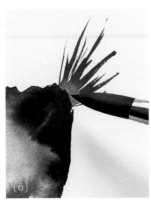

{6}

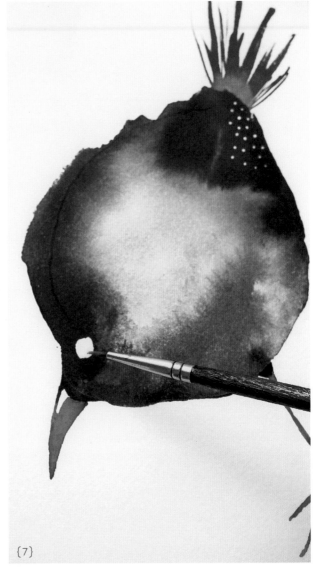

{7}

{1} Using a wet brush, create a rough circle on the paper that will be the bird's body, and let it dry for a minute or two. {2} With a big brush, drip some watercolours on the moistened area and let the colours bleed within that area. {3} Soak up the excess water with a sponge, and add more colour and water as necessary to mix the colour in the shape into a nice pattern. {4} Use a brush to add some black watercolour to make the shape of the bird more distinct. {5} Wait until the paint is dry, then take a thin brush and paint in the beak and feet with orange paint, using small, neat strokes. {6} Paint the tail feathers using a medium-sized brush, hairbrush, comb or toothbrush to give a spiky effect. {7} Let it dry. Then paint some small white dots onto the bird for texture, and give the bird an eye with a larger white dot. Again, let it dry so the paint doesn't bleed, then add a tiny black dot on top to complete the eye.

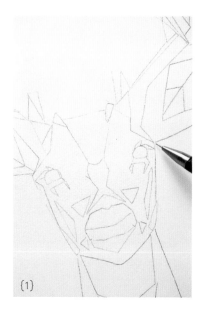

{1}

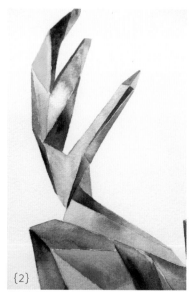

{2}

{3}

GEOMETRIC STYLE: DEER HEAD

This is a modern and graphic way of depicting animals and I love that the variations in light and dark make the image look iridescent. Liquid watercolour or pans will work best, as you want a light, transparent effect.

{1} Draw out the deer head in pencil, using straight-sided shapes to make up the whole and create the geometric effect. {2–3} With a small brush, fill in each shape with different colours. I've chosen a palette of natural colours with a few bright ones as accents. Use your brush to create variations in shade within each shape, by adding more paint or water. You don't want the areas to bleed into each other, however, so allow them to dry before painting adjacent ones. {4} When it's dry, you might want to take the illustration further by adding collage. Cut out watercolour textures to fit into some of the shapes of the deer head and fix them in place with adhesive. The mix of painted illustration and watercolour textures makes for a striking combination.

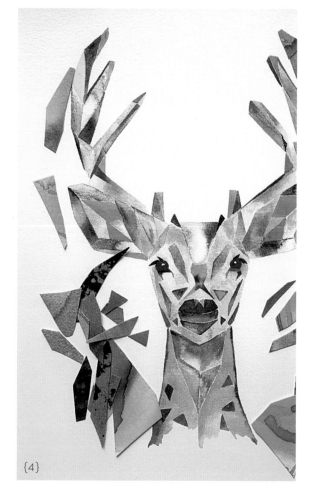

{4}

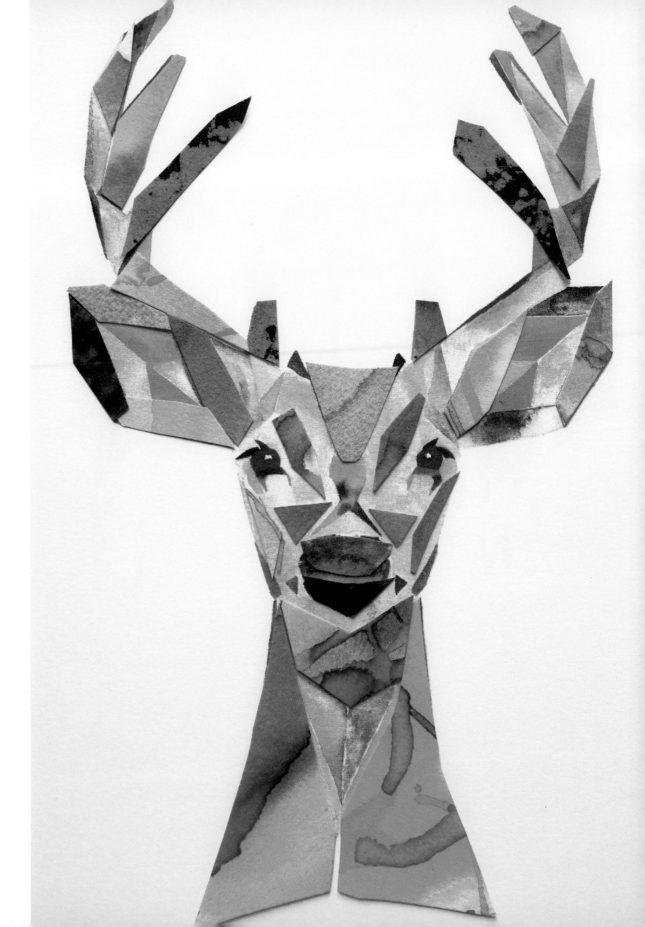

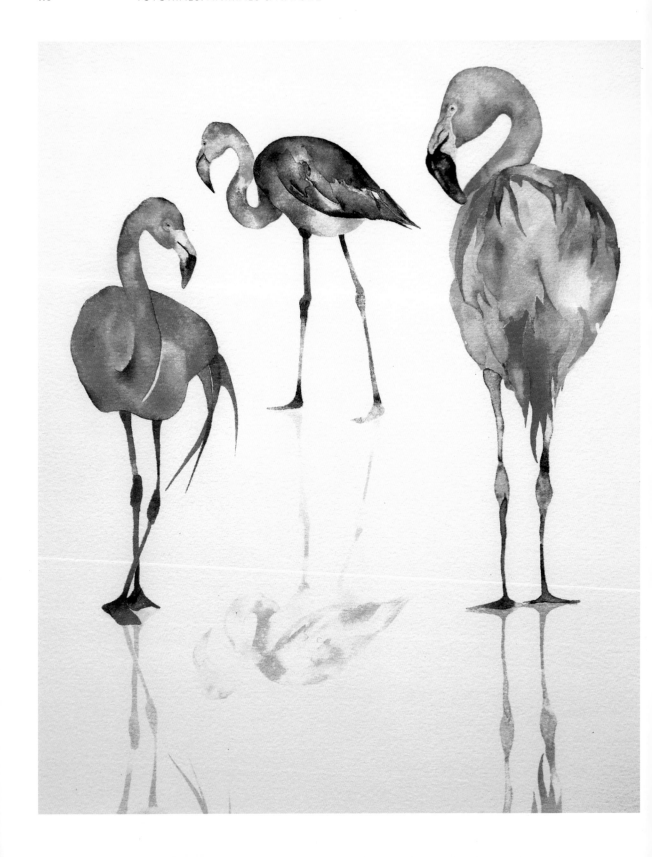

REFLECTIONS: FLAMINGOS

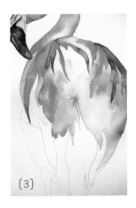

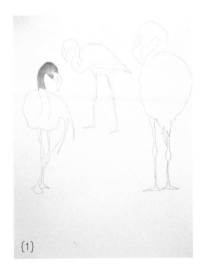

{1}

{2}

{3}

{4}

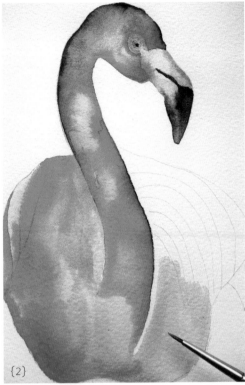

{5}

A group of flamingos, with their elegant shapes, makes a lovely illustration, and you can be as wild and fantastical with your colour choices as you like.

{1} Mark out the flamingos in pencil. Choose a different colour for each flamingo and start filling in each one with light shades of watercolour. As usual, it's easiest if you start at the top of the paper and work downwards. {2-4} Add in darker shades to create shadows and textures. {5} When you have finished painting the flamingos, add in the reflections to make the birds look as though they're walking on water. Do this with very light, watered-down shades of the main colour you used for each bird, using a thin brush.

* TIP: The trick to painting effective reflections is to make the colours darker the closer they are to the object – here, the flamingos' feet – and lighter as they get further away.

BLEACH DETAILS: FLOWER

This is a flower illustration with added bleach texture, giving it a subtle style reminiscent of traditional botanical images.

{1} Draw out the flower in pencil. {2} Paint the flower, starting with the light tones, then adding darker ones for shadows, textures and details. Using a very thin brush, add in some outlines to clarify the different parts of the flower and leaves. {3} Drip some bleach onto parts of the flower and the leaves, using a cotton bud or old brush. You will see that some white areas appear. {4} Let the paint dry and use a darker brown colour to paint in the flower stamens.

{1}

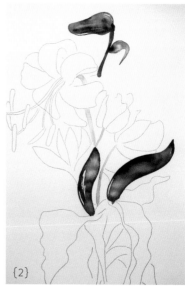

{2}

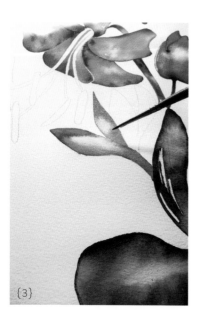

{3}

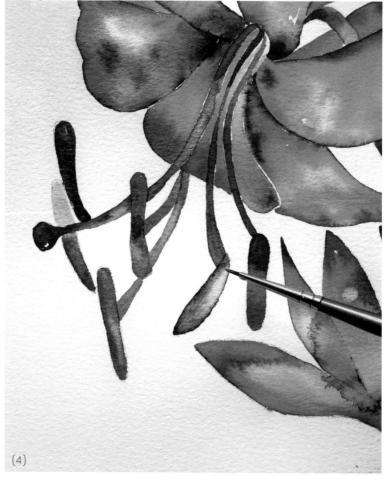

{4}

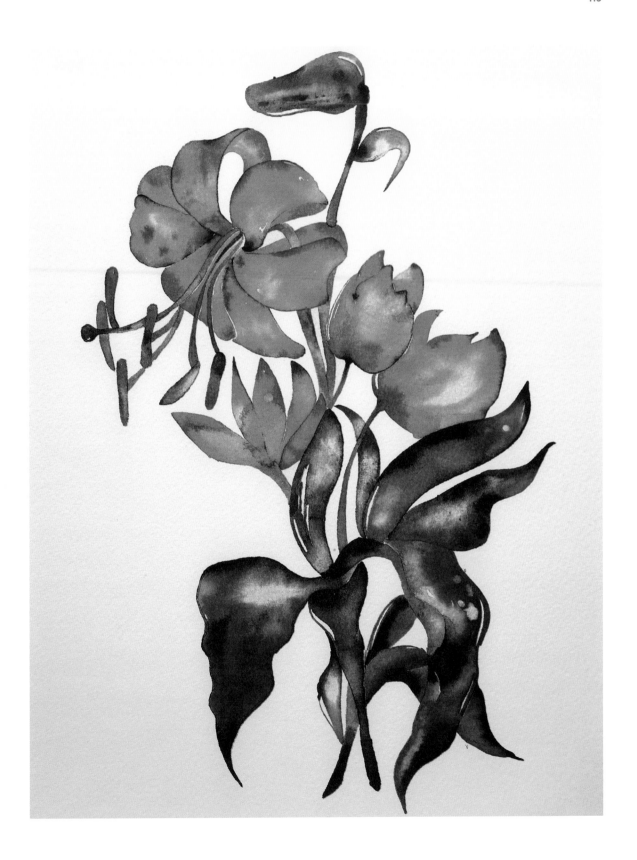

BLENDING COLOUR: WHALES

This composition featuring a group of whales demonstrates a contemporary approach to a more traditional layering technique with watercolour. Here, the medium is an excellent way to explore texture and light.

{1}

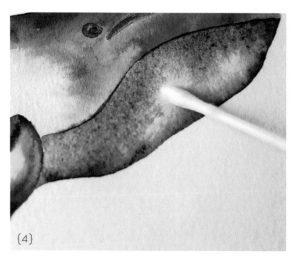

{2}

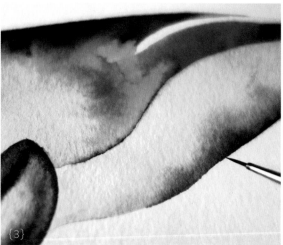

{3}

{4}

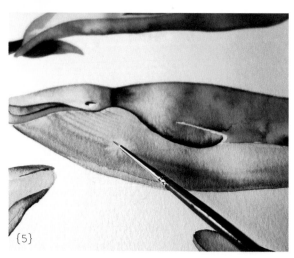

{5}

* **TIP:** When painting final details, it's best to work with a fairly dry base so that you have more control over the paint.

{1} Sketch out the composition in pencil; then, using a fine brush, start painting the light base colours. Mix colours of similar tones with lots of water to create an even, silky texture. {2} Wait for the base layer to dry, then build up the next layers of colour for each of the whales. Add a little water to the area you're about to paint before you apply darker colours to blend them more easily. While you want some bleeding within the different areas, you want the areas themselves to remain distinct, so wait for the paint to dry before working on adjoining ones. {3} Take a smaller brush and start darkening the contours, again adding a little water to the page so that the edges you're painting blend in seamlessly. {4} To create lighter areas, soak up paint using a cotton bud, and to make them even lighter, add more water and re-apply the cotton bud. {5} Wait for everything to dry before adding the final, darker details.

CITYSCAPES

MAP: MANHATTAN

Manhattan works really well as a coloured-in map because of the way it's divided up, and by adding hand lettering in black ink to mark out the area and neighbourhood names, the contrast makes for a lovely graphic-design illustration.

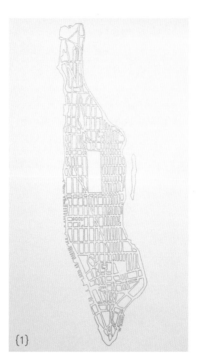

{1}

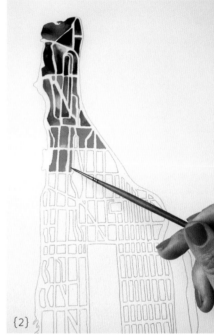

{2}

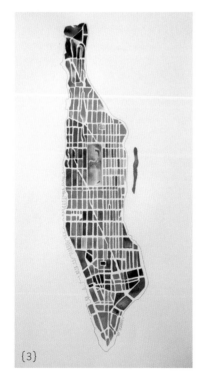

{3}

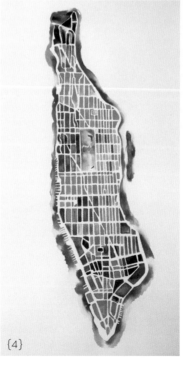

{4}

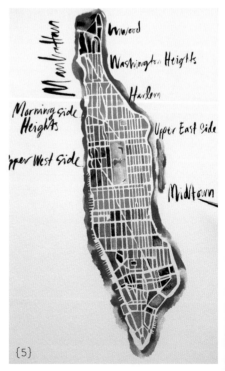

{5}

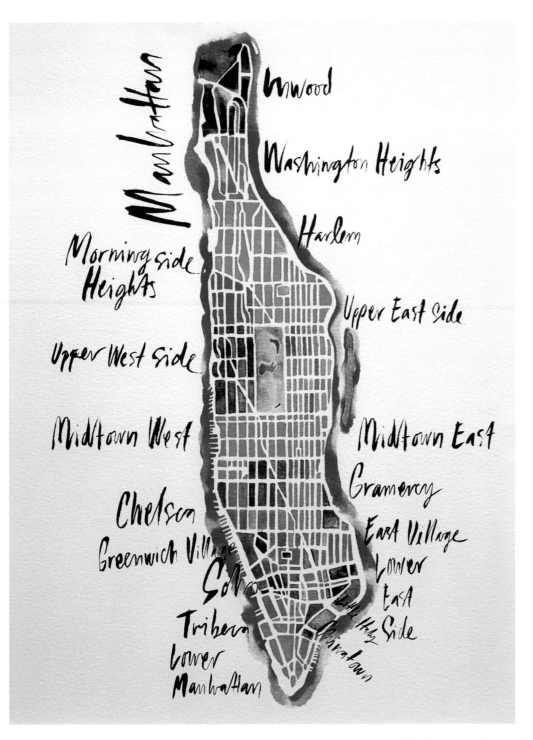

{1} Draw out the map of the island in pencil. {2-3} Working from the top of the map down, paint each of the zones in a different colour – it's easiest if you use a thin brush, and both solid or liquid watercolours work well for this. Vary the tones of each colour within the zones by adding more or less water to the paint to give a more lively feel to the image. {4} Next, paint a soft blue outline around the island to indicate the water. {5} When the paint is dry, use black ink and a thin brush to write the names of the different neighbourhoods over the top of the map, keeping the style deliberately casual.

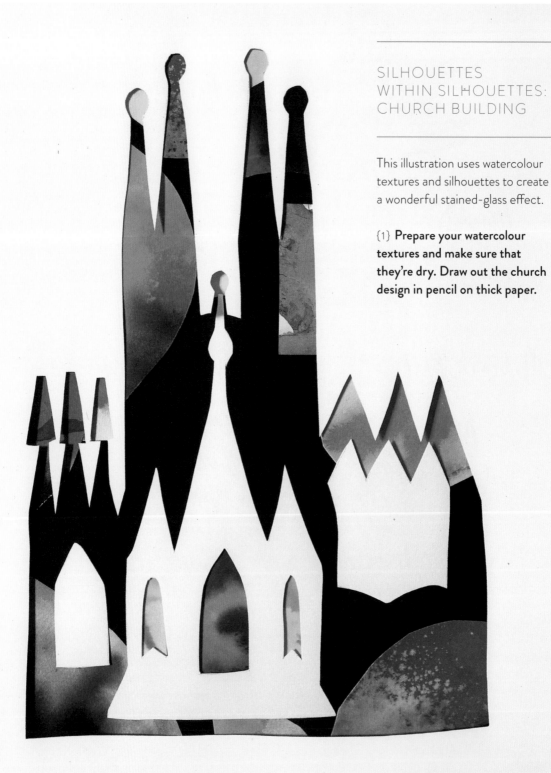

SILHOUETTES WITHIN SILHOUETTES: CHURCH BUILDING

This illustration uses watercolour textures and silhouettes to create a wonderful stained-glass effect.

{1} **Prepare your watercolour textures and make sure that they're dry. Draw out the church design in pencil on thick paper.**

{1}

{3}

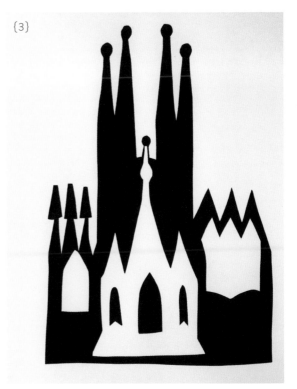

{2}

{2-3} Use a scalpel or cutter to cut out the silhouette and its inside parts, working from the inside of the illustration outwards. Keep all of the cut-out parts as you will need them to place over the textures.

{4} Cut out your textures into interesting shapes. Arrange these under the cut-out silhouettes, backing the illustration onto a contrasting piece of paper (here, the silhouette paper is white and the backing is black), which shows through with the textured pieces. When you're happy with the way it looks, glue all the elements into place.

{4}

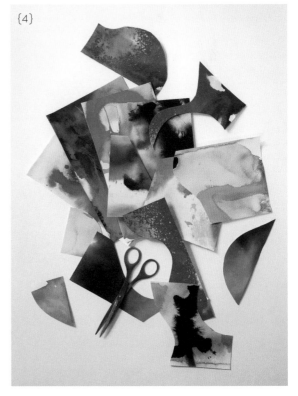

SIMPLE SHAPES: LONDON

In this illustration, I've painted London's iconic landmarks as simple shapes, and used only blue, black and grey colours to suggest the city's distinctive smoky look.

{1} **Sketch the scene in pencil on watercolour paper.** {2-4} **Start filling in the outlines – I prefer liquid watercolours here – and use darker tones for the tops of the buildings, blending into lighter blues as you move down them. Use your brush to soak up colour to lighten areas, and to add black and grey for shadows. Let buildings dry before working on adjacent ones.** {5} **When the paint is dry, use black to paint the bus and add any details for definition.**

{1}

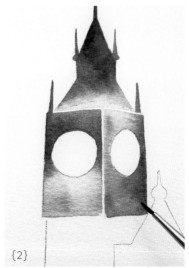

{2}

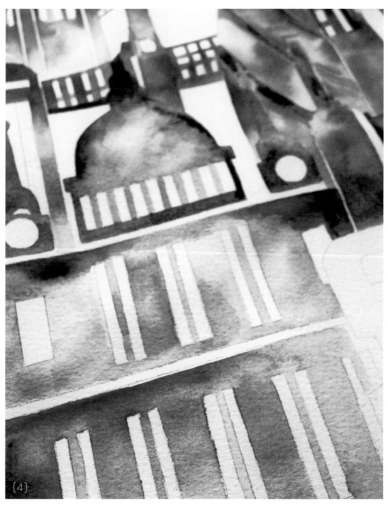

{4}

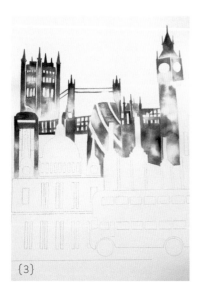

{3}

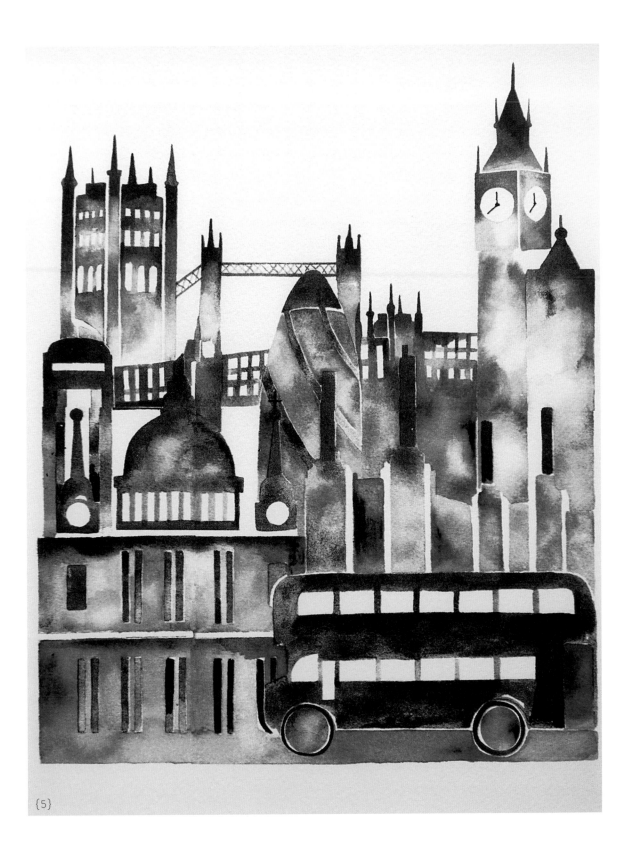

{5}

COLLAGE COMPOSITIONS: BARCELONA

This collage is created from well-known Barcelona landmarks. There are infinite ways you can arrange them, and you can apply the technique to anywhere!

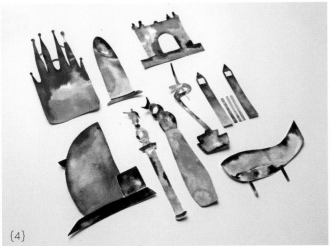

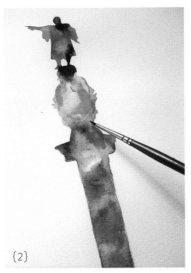

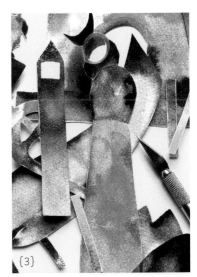

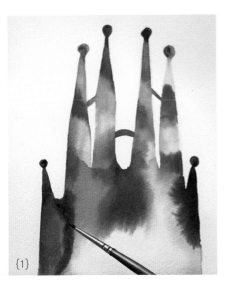

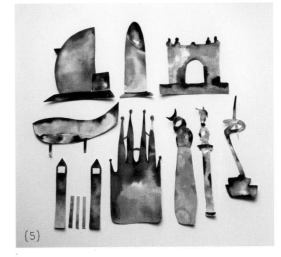

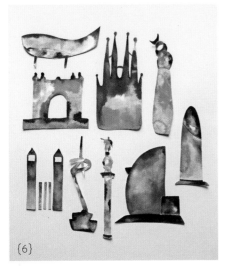

{1-2} Draw out all the landmarks in pencil on thick watercolour paper. Paint each one, using liquid watercolour mixed with plenty of water and a medium brush. Use two tones of watercolour for each landmark only, adding water to lighten, and black and grey to add shadows, but don't add too many details as you want to keep the landmarks bold and stylized. Use a palette of a few colours only for all the buildings so that they complement each other. {3} When the landmarks are dry, cut them out. {4-6} Arrange them on a sheet of paper. You can create whatever composition you like, whether that's grouping them together or lining them up as part of a composite skyline. With cut-outs like these, it's easy to test out compositions on a page. When you're happy with the layout, fix the landmarks in place with adhesive.

SKYLINE/REFLECTION: NEW YORK

I have always enjoyed painting cityscapes and the iconic New York skyline is ideal for a stylized illustration. This one showcases a very forgiving method of blending and diffusion. A pink and black colour palette harmonizes the silhouettes, and there is a nice contrast between the sharp skyline and gentle blurred reflection.

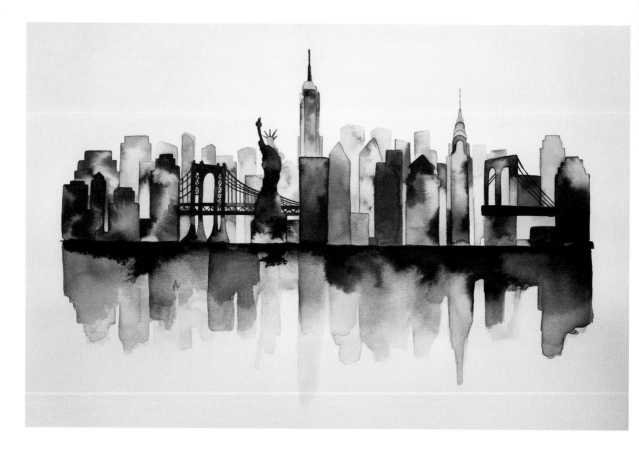

{1} Start with a sketch of the skyline in pencil. For the outline of the reflection, you will probably find it easiest to flip the paper upside down and draw a mirrored version. {2} With the paper the right way up again, paint in the background buildings using very light pink and pale grey tones. {3} Paint the buildings in the foreground in darker pink and black tones to create a sense of depth. Don't worry about the colours merging within each building, but try to keep their outlines as clean as possible by allowing buildings to dry before painting adjacent ones. Leave the image to dry completely. {4} Once dry, begin the mirror image. Add plenty of water to the paper with your brush where you're going to paint the reflection, then let it dry slightly for a few minutes before starting to add the very light tones. Use a contrasting colour to differentiate the reflection; here, I have kept within the pink theme but used more of a red tone for the reflection. {5} Now work on strengthening the edges

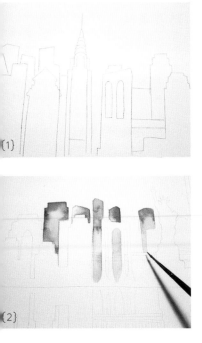

{1}

{2}

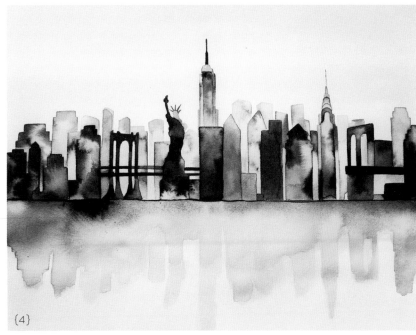

{4}

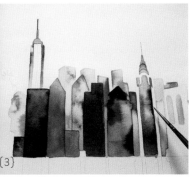

{3}

{5}

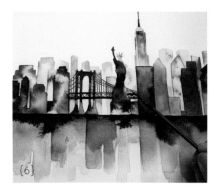

{6}

* **TIP:** Use Chinese ink to go over black detailing and give the illustration extra crispness, especially as this contrasts with the blurred paint effects.

of the buildings in the mirror image. Use darker tones to distinguish the foreground buildings from the background ones, applying colour from the top and working down the page. Then add black detailing to the bridges and windows of the upper skyline image – it shouldn't bleed as the upper skyline should be dry. Next, while the reflection is still fairly wet, add black to the mirror image along the reflection line, and allow it to blur and diffuse down the reflection. If you want to add a more watery effect, use a hair dryer to blow the paint, taking care to direct the nozzle down the reflection only. {6} When everything is dry, sharpen the edges of your buildings and any details using Chinese ink and a fine brush. If you want the reflection to appear even blurrier, add more water to fade and blend it.

INDEX

I would like to thank my agents, Lisa, Kiki and Kajsa;
my sister, Nathalie; and Curtis.

The publisher would like to thank Alannah Moore,
Louise Evans, Julie Weir, Lucy Carter and everyone
at Ilex for their hard work on this book.